IMAGES
of America

OGDEN

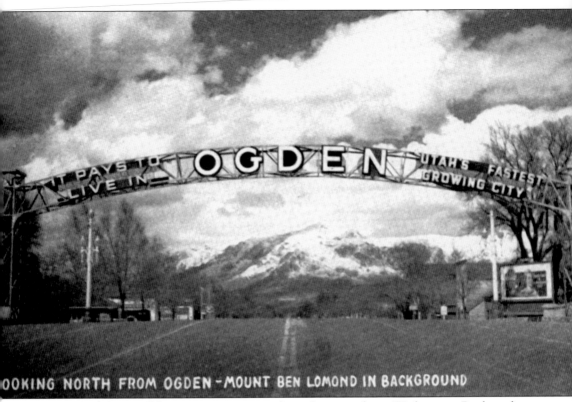

OOKING NORTH FROM OGDEN - MOUNT BEN LOMOND IN BACKGROUND

One of Ogden's well-known monuments is the welcome arch on Washington Boulevard near Eighteenth Street. The sign says, "It Pays to Live in Ogden" and "Utah's Fastest Growing City." In the 1950s, the sign was changed to add "Home of Weber State" on the right. Mount Ben Lomond stands sentinel in the background. (Courtesy of Weber State University Special Collections.)

ON THE COVER: Ogden residents join representatives of the Union Pacific and Southern Pacific railroads, along with Utah governor J. Bracken Lee, in dedicating a monument at Union Station commemorating the driving of the golden spike. At the May 10, 1951, event, Governor Lee said it was a "fitting tribute" to the role Utah and Ogden played in the "building of the West." (Courtesy of Weber State University Special Collections.)

IMAGES
of America

OGDEN

John Sillito and Sarah Langsdon

ARCADIA
PUBLISHING

Copyright © 2008 by John Sillito and Sarah Langsdon
ISBN 978-0-7385-5879-0

Published by Arcadia Publishing
Charleston SC, Chicago IL, Portsmouth NH, San Francisco CA

Printed in the United States of America

Library of Congress Catalog Card Number: 2008925028

For all general information contact Arcadia Publishing at:
Telephone 843-853-2070
Fax 843-853-0044
E-mail sales@arcadiapublishing.com
For customer service and orders:
Toll-Free 1-888-313-2665

Visit us on the Internet at www.arcadiapublishing.com

John Sillito: To my fellow "Ogdentinos,"
Linda and Cynthia, who share the journey.

Sarah Langsdon: To my husband, Michael,
and my children, Cade and Sophie,
who allowed me the time to work on this project
and understood the importance of it.

CONTENTS

ACKNOWLEDGMENTS

Since the Special Collections Department was created at Weber State University's Stewart Library, the department has sought to document the history of Ogden City and the surrounding counties. The materials housed within the department offer a myriad of stories and information about the community's history in manuscript collections, photographs, and printed sources. This book documents some of those stories through photographs. Unless noted, all the images used are part of the holdings at Weber State University. In particular, the Ogden Chamber of Commerce, Loni Prout, Richard Roberts, Charles MacCarthy Glass Plate Negatives, and Glenn Perrins photograph collections were utilized for their wonderful images. We appreciate several people for their help in obtaining photographs: Roy Webb, multimedia archivist at the University of Utah; the Utah State Historical Society; photographers John Shupe and Jessica Johnson; Sr. Luke Hoschette and the Mount Benedict Monastery; and Scott Paulus and Ken Spindler of the Milwaukee Brewers.

We thank our editor at Arcadia Publishing, Hannah Carney, who first approached us with the idea for a book on Ogden and then guided and prodded us through the process. After Hannah left, Jared Jackson stepped in to finish the project. We would also like to thank the staff in Special Collections and Archives, Melissa Johnson, Janessa Knotts, and Patti Umscheid, who helped research photographs and picked up the slack. University Librarian Joan Hubbard supported this process from the beginning, and we offer her our appreciation.

Several people have paved the way for this book through their research, writing, and enthusiasm for Ogden's history. First are Richard Roberts and Richard Sadler, who are responsible for the definitive histories on Ogden and Weber County. Next is Milton R. Hunter, who wrote the first history on Ogden under the direction of the Weber Chapter of the Daughters of Utah Pioneers. D. Boyd Crawford's *Ogden in Post Cards* was most helpful. Finally, we express our gratitude to the Mountain West Digital Library and their growing archives of digital Ogden newspapers. Without that resource, and the microfilmed copies of the *Standard-Examiner* and other Ogden newspapers, no chronicler—past or present—can tell Ogden's story.

INTRODUCTION

On April 26, 2008, commuter rail service returned to Utah after an absence of many decades. Fittingly, the northernmost terminus of the line (at least for a time) would be Ogden. That morning, according to the *Standard-Examiner*, the town's newspaper, Mayor Matthew Godfrey gathered with a group of dignitaries and Ogden residents near Union Station to welcome the "red, white and blue FrontRunner train" whose "shrill whistle . . . punctuated the cool morning air." Godfrey "enthusiastically" assured the crowd that the new commuter line "opened the door to people up and down the Wasatch Front to visit Ogden." In many ways, the revival of commuter rails replicated an earlier time when Ogden became the "Junction City" of Utah—the state's most important crossroads of lines going both north-south and east-west. But Ogden's impact and importance predates the arrival of the Mormon pioneers in 1847, the expansion of the railroads in 1869, and statehood in 1896. That story is captured through the images in this book.

From the earliest days, what is now Ogden—and more broadly Weber County—was an area where Native Americans, mountain men, and fur trappers gathered to meet and trade. The wide valley—where the town presently is situated—was located near the confluence of two important rivers, the Ogden and the Weber. In 1845, Miles Goodyear established a settlement he called Fort Buenaventura on the banks of the Weber River. Two years later, Goodyear met the westward-traveling Mormon immigrants and offered them his settlement, which they purchased in November 1847. By the spring of 1848, Mormon leader Brigham Young had called a number of settlers to populate the area, especially James Brown and Lorin Farr and their families. At first, the settlements were known by a variety of names. Particularly important was Brown's Fort, later called Brownsville. Ultimately, in 1850, at Young's direction, the name "Ogden" was given to this settlement in recognition of Peter Skeene Ogden, a Hudson's Bay Company fur trapper who had worked in the valley and adjacent mountains in the 1820s. Lorin Farr became the first mayor, and Ogden city officials regard February 6, 1851, as its founding date. The county was named for John Weber, another trapper.

During the next two decades, the various settlements along the Weber and Ogden Rivers prospered, and Ogden itself grew into an important, if modest, agricultural town north of Salt Lake City. Key to that growth was the availability of water, brought in from nearby streams and rivers. Over the years, the creation of Pine View Dam and the Weber Basin Project expanded the availability of water. With the driving of the golden spike in 1869 some 25 miles northwest in Corinne, Ogden changed dramatically into a significant commercial, railroading, and banking center as well.

Somewhat culturally diverse by Utah standards, Ogden emerged in the latter part of the 19th century as a factor in Utah's religious and political life. While the Mormon presence in Ogden was profound, and in many ways defining, other religious groups came to the area at an early date. The Episcopal Church arrived in the 1870s, and its Church of the Good Shepherd still stands 133 years later. Presbyterians, Methodists, Baptists, Catholics, and others all called Ogden home. Recently, a growing Hispanic population has swelled Ogden's Catholic community and led to several Spanish-language newspapers and businesses.

In 19th-century Utah, however, divisions between Mormons and "Gentiles" (non-Mormons in local parlance) dominated civic and political life. Elections were fiercely contested between a Mormon People's Party and a non-Mormon Liberal party. In 1889, the election of the Liberal mayoral candidate Fred Kiesel represented a shift away from Mormon control of political life. With the coming of statehood, local politics took on the coloration of national politics, featuring Republicans, Democrats, and (in the early 20th century) even Socialists.

As the Weber County seat, Ogden continued its rise as a major economic and commercial area. While railroading continued as a major economic force, with important shipping lines east-west and north-south, Ogden also became a center for manufacturing, construction, livestock, and agriculture. Among the most important economic concerns was the Utah Construction Company (UCC), founded in 1900. During the next 75 years, the company's impact increased, and it would become important nationally and internationally. For example, UCC sparked the organization of the "Six Companies," which built the Hoover Dam during the Great Depression. The company reflected the involvement of some of Ogden's and Utah's most important economic leaders, including David Eccles, Thomas D. Dee, and the Wattis brothers—William, Edmund, and Warren. Other important companies included Amalgamated Sugar, Utah Canning Company, Browning Arms, and many others.

While business and industry dominated, tourism developed as an important economic activity. In the early days, this was tied to the railroads. But over time, the American passion for automobile travel brought people through town and up Ogden Canyon to its water recreation and skiing. The influx of people coming into Ogden also had something to do with the development of one of its most well-known attractions—Twenty-fifth Street. Situated near Union Station, only a few blocks from the business district, the notorious "two-bit street" was known for the availability of vice—drugs, gambling, and prostitution. A jazz scene developed in the area as well, in part because of Ogden's black population and its ties to the railroad. Local and nationally known musicians alike played at the Porters and Waiters and other clubs.

Hit hard by the Great Depression of the 1930s, Ogden recovered as a result of an economic boom in military contracts during World War II with the construction of the Defense Depot Ogden, the Naval Supply Depot, Hill Air Field, a major POW camp, and other facilities. By then, more than 100 troop trains passed through the town daily.

In 1951, Ogden marked its centennial. As part of the celebration, in May, a monument was dedicated at Union Station commemorating the driving of the golden spike 82 years before. Utah governor J. Bracken Lee told those in attendance that a transcontinental railroad was a dream of Brigham Young and the Mormon settlers long before "the actual construction of the vital railway network." Governor Lee celebrated the railroads' "far-reaching effects in the economic life of America and the world." While he was correct, changes were coming, and Ogden's economy revolved less and less around railroading.

In the past 50 years, Ogden has remained an important economic area of the state by diversifying. Weber State University has been a major force in Ogden's educational life. Established in 1889 as Weber Stake Academy, the school was administered by the Latter-day Saints (LDS) Church until it became a state school in the 1930s. Since that time, it has gone from a two-year college to a four-year university. As such, it is a major employer and boasts a student body of 18,000. In the postwar period, an IRS center in Ogden provided employment, and an industrial park brought in many new companies. An active public/private partnership is currently expanding the downtown area, focusing on restoring Twenty-fifth Street and enhanced by the expansion of Lindquist Field (home of the Ogden Raptors) and the new Junction, an entertainment, retail, and residential complex. In addition, a number of ski-related manufacturing concerns recently have located in Ogden.

Ogden celebrated it sesquicentennial in 2001 with a year-long series of events. Today it is a vibrant and growing community. Commercial, cultural, and educational projects all suggest that Ogden's next 150 years will prove as significant as its first.

One

TAKING OGDEN
TO THE STREETS

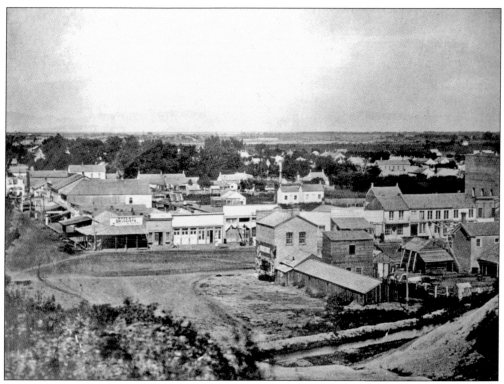

Taken in 1876, this shot of Ogden is one of the earliest in existence. It was taken at Twenty-fifth Street and Washington Boulevard. On the corner is W. A. Wade and Company, which was one of the first drugstores in Ogden and started in 1875. The store became popular with the citizens of Ogden and tourists because of the neatness of the store and knowledge of Wade.

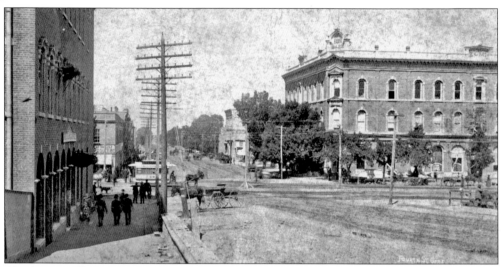

Charles Russell Savage was a prominent Utah photographer who shot images throughout the West. This is a *c.* 1900 photograph looking west down Twenty-fourth Street from just above Washington Boulevard. On the right is the First National Bank in the ZCMI building. ZCMI was the Zion's Cooperative Mercantile Institution, one of the United States' first department stores, founded by the LDS Church in 1868.

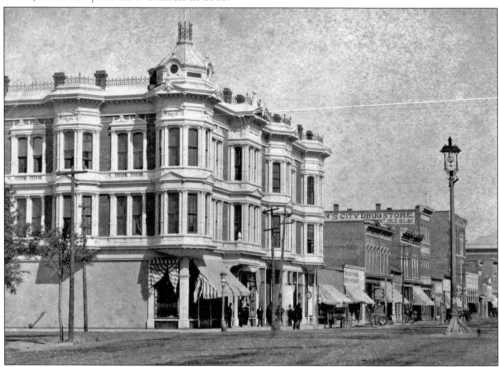

Before the start of the 20th century, Twenty-fifth Street and Washington Boulevard was a major destination for tourists in Ogden. Looking north is the Broom Hotel, Ogden's City Drug Store, and the First National Bank. The First National Bank was one of the first banking institutions to open in Ogden. The Broom Hotel, which opened in 1885, was billed as the best hotel between San Francisco, California, and Denver, Colorado.

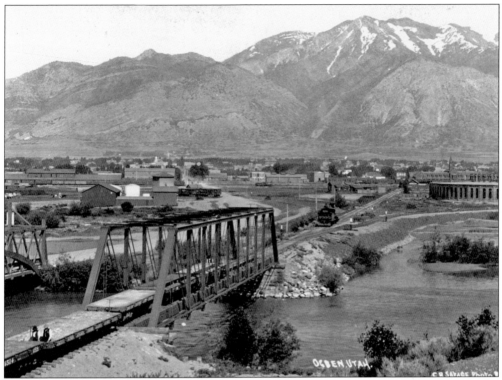

This photograph was taken by Charles R. Savage in West Ogden. It depicts the railroad bridge that crossed the Ogden River into the railroad yards in downtown Ogden. Ogden became a major railroad hub of the Intermountain West. The railroad made Ogden more attractive as a commercial center and a financial and shipping base for the entire region.

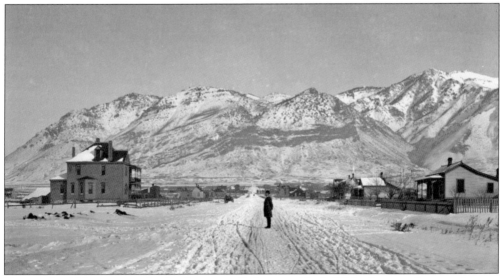

During the 19th century, the landscape in Ogden was bleak. This photograph was taken on Twenty-fifth Street looking east from Monroe Boulevard, which is east of Washington Boulevard. The street is dotted with a few family homes, but nothing compared to the bustling city located just a few blocks west.

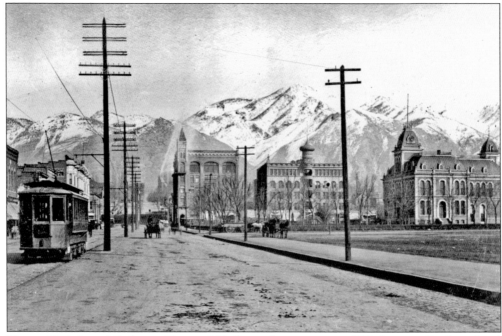

This *c.* 1900 shot of Ogden on Twenty-fifth Street faces east toward Washington Boulevard and the mountains. Pictured is the Reed Hotel, one of Ogden's earliest and finest before it was torn down in 1927. Also shown is the Orpheum Theater, which hosted many plays, singing acts, and vaudeville, and the old city hall.

In the 1920s, this photograph was taken from the Elks Club near Twenty-fifth Street and Grant Avenue looking east toward the mountains. The Municipal Park is in the foreground with the statue formation seen in the clearing. The other noteworthy buildings are the Reed Hotel, the Orpheum Theater, the Broom Hotel, and the Weber County Courthouse tower farther north down Washington Boulevard.

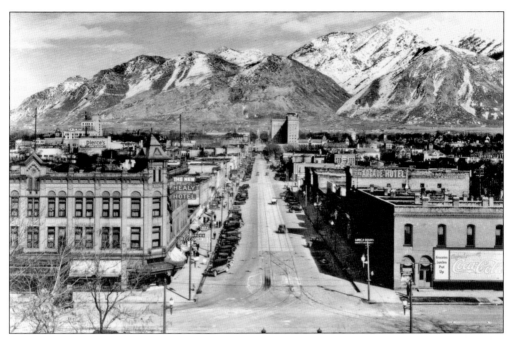

With the railroad at its center, Ogden grew around the Union Station on Twenty-fifth Street and Wall Avenue. These two photographs show the area immediately east of the Union Station up Twenty-fifth Street. The top photograph was taken from the roof of the Union Station and shows the Healy Hotel, the Arcade Hotel, and the Bigelow Hotel. It also shows the large Coca-Cola sign on the side of a building, the Pierce's Pork and Beans sign, and the sign for Becco near the Healy Hotel. Becco was manufactured by the Becker Brewing and Malting Company during Prohibition as a non-alcoholic alternative to their popular beer products. The bottom photograph is taken from the street level during an earlier time period. It also shows the numerous drugstores and little hotels offering rooms that lined Twenty-fifth Street.

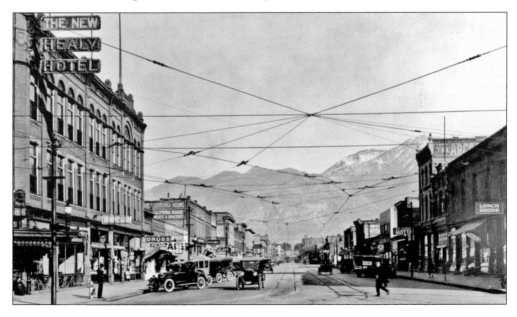

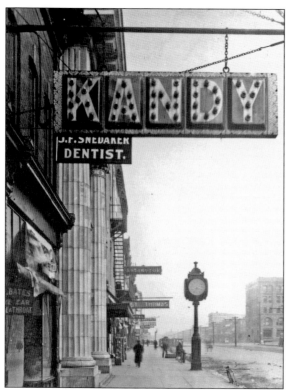

This photograph looks north along the west side of Washington Boulevard toward Twenty-fourth Street. The large sign belonged to the Kolitz Kandy Kitchen, which opened in 1899. The candy company was known for its old-fashioned butternut taffy. The two Greek pillars mark the entrance of the Pingree Bank, which was started by James Pingree. The clock out front belongs to the John S. Lewis Jewelry Store.

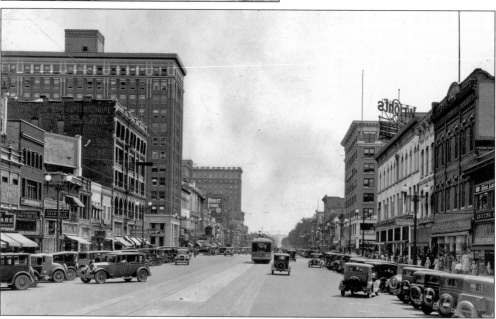

Looking south down Washington Boulevard from Twenty-third Street, the businesses show the growing economy of Ogden in 1927. The tall buildings on the left are the First Security Bank and the Bigelow Hotel. On the right are the Eccles Building and the W. H. Wright Department store. The smaller businesses include Dick's Cafe, Shoe Land, Ogden Hardware Company, Bramwell's, and E. C. Stratford Furniture Company.

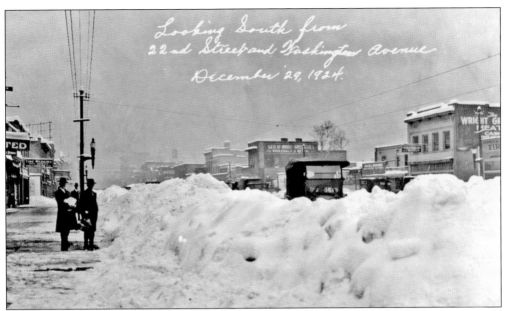

Looking South from 22nd Street and Washington Avenue December 29, 1924.

Even before skiing became a major attraction in the mountains of Ogden, the area was still known for its great snow accumulation. The winters in the 1920s were especially harsh, with large amounts of snow. The top photograph shows Twenty-second Street and Washington Boulevard looking south on December 29, 1924. The *Ogden Standard* called 1924 the "year of the harsh winter." The temperatures dropped down to 20 below zero and killed off many farm animals. The snow piled so high next to the streets after 37 straight hours of snowfall that one almost cannot see the cars driving down Twenty-second Street. The bottom photograph was taken five years later, in 1929 on Twenty-fifth Street and Kiesel Avenue. It shows city hall and the Hotel Bigelow, along with the trolley cars that ran down the street.

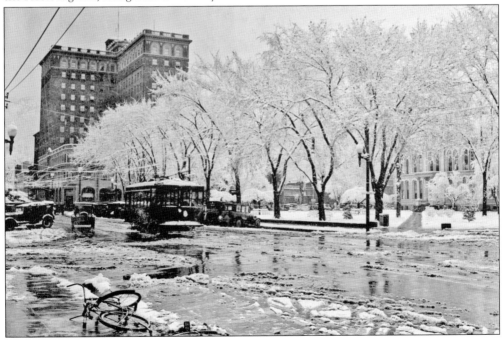

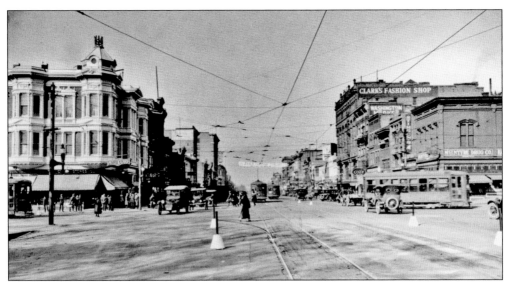

In this *c.* 1923 photograph looking north up Washington Boulevard from Twenty-fifth Street, the trolley cars and car traffic are at center. On the left is the Broom Hotel, with the McIntyre Drug Company just across the street. In 1923, the A. R. McIntyre Drug Company began offering its customers a money-back guarantee on products such as "nuxated iron." The banner running across Washington advertises the Elks Indoor Circus.

By the late 1960s, Ogden had become a bustling city with the center of business on Twenty-fifth Street. This scene looks west down this street toward the Union Station. Twenty-fifth Street was often known as "the street that never slept." It offered all the carnal delights for tourists and Ogdenites. Seen here are many restaurants and stores, along with the Marion Hotel and the Greyhound Bus Depot.

Two

JUNCTION CITY
THE GATEWAY TO THE WEST

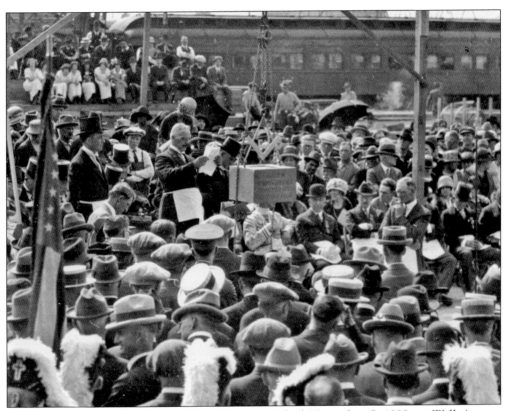

The cornerstone for the Ogden Union Depot was laid November 5, 1888, at Wall Avenue and Twenty-fifth Street. The architect for the new building was Henry Van Brunt. More than 5,000 people, including Masonic representatives, came to the event. Parley L. Williams delivered the keynote address, in which he remarked, "Thus, aside from its principal object as a public comfort and convenience, it will become . . . an ornament to your city and locality."

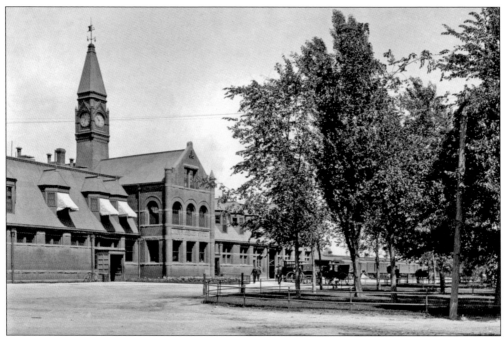

The original Union Depot had two-story north and south wings with a three-story center section. The large electric clock in the tower was donated by Ogden jeweler John S. Lewis. It was installed below a decorative weather vane. The *Ogden Standard* described the new station in 1885 as "a depot building worthy the point of center for the great transcontinental highways."

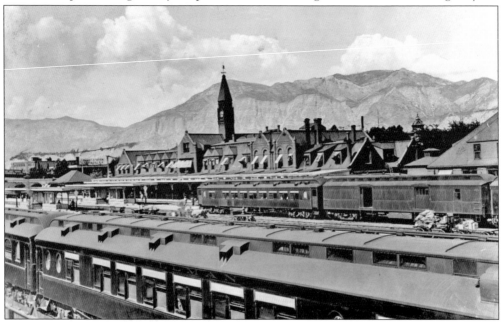

Around the dawn of the 20th century, the Ogden Union Depot saw the constant activity of 200 train crews to handle the freight and passengers of the approximately 70 incoming trains. The engine and repair shops were staffed by an additional 800 workers, making the Union Depot and yard Ogden's major employer during that time.

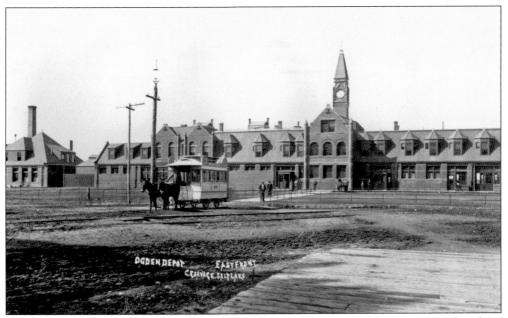

The railroad turned Ogden from an "inland town" into a major city of commerce and trade to outside areas. The major railroad thoroughfare was the Ogden Union Depot. The depot was completed in 1889 and served admirably for 34 years until it was destroyed by fire in February 1923. The depot was a two-story building with a waiting room, ticket office, café, railroad offices, and even a hotel that operated 30 rooms. The blaze started in the hotel room of a porter who failed to unplug his electric iron after pressing his uniform. It took several hours to control the fire, and only a few offices and the ticket counter were fit for use after the fire.

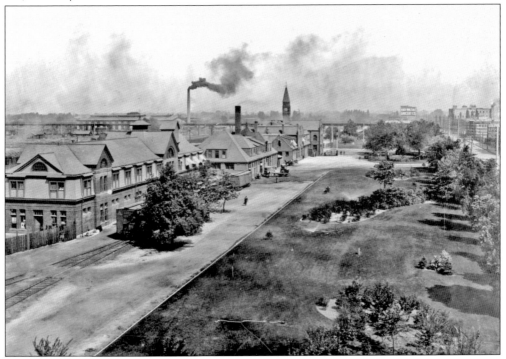

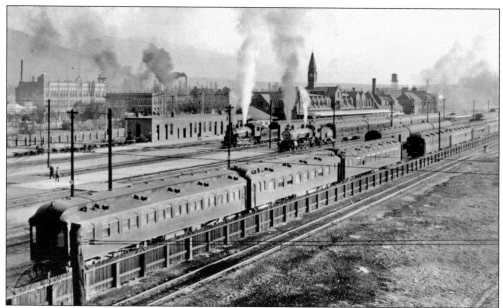

When the Union Depot was completed in 1889, Union Pacific president Charles Adams had promised that seven railroads would now stop in Ogden and another two would be added within two years. Mayor David Eccles said, "The hour has come, when Ogden would be recognized abroad, as at home, the great railway center of the intermountain region."

Along with passenger trains, the Ogden station saw U.S. mail trains, which were housed in a brick building north of the main depot. The station was home to Western Union telegraph and stationmaster offices. Big doors in the back of the station opened onto the waiting platform and a subway connecting eight shaded tracks.

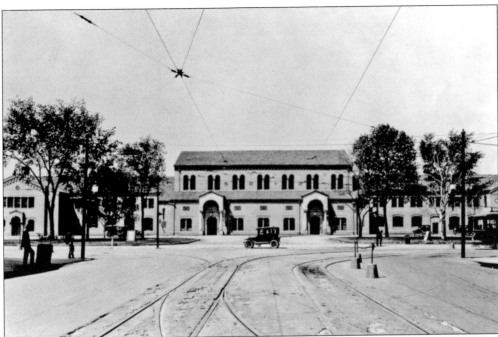

Immediately after the fire in 1923, Los Angeles architects John and Donald Parkinson were commissioned to design the new station. The two-story structure was 374 feet long and had a Spanish tile roof. It had a main-floor restaurant that held 150 patrons, a large baggage room, barbershop, men's smoking room, women's rest area, and an emergency medical facility. During World War II, thousands of GIs stopped in Ogden to enjoy the hospitality provided by the local USO. With the decrease in railroad traffic by the 1970s, Union Station was converted into a convention center and museum, with all train service stopping by 1998.

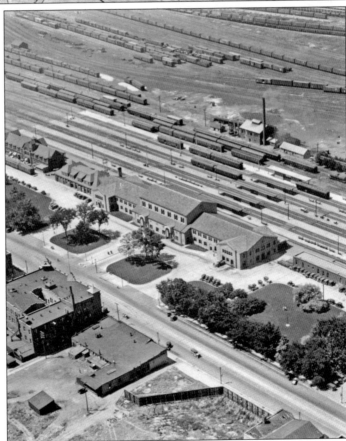

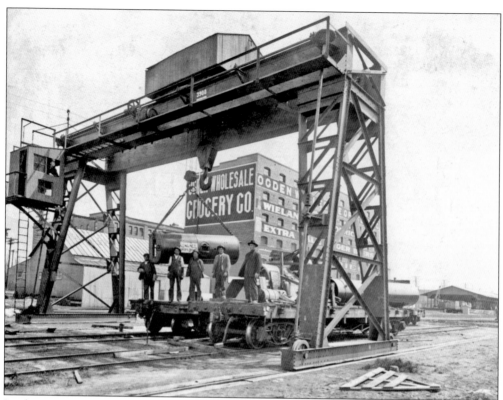

In the 1920s, the Union Pacific Railroad Company joined up with Oregon Short Line and Southern Pacific to form a joint freight agency that operated out of the Ogden Union yards. Pictured here are some of the workers on a train line behind the Ogden Wholesale Grocery Company. Ogden was the natural shipping point for Utah, Nevada, Idaho, and Montana because of its central position in the West.

The first electric railway to operate was the Ogden Electric Railway, started in 1891. The trains took passengers around Ogden, as well as up Ogden Canyon. Ogden was also a major stop on the Bamberger Electric that left Ogden every hour and took people to Lagoon (a summer resort near Farmington) and Salt Lake City. This is a streetcar crossing Wall Avenue Bridge in 1952.

Three

THE FOUNDATIONS
OF FAITH

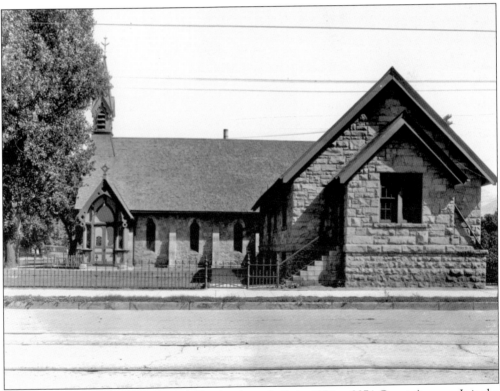

The Episcopal Church of the Good Shepherd was built in 1874 at 2374 Grant Avenue. It is the oldest building in Ogden in continuous use. It was the gift of the Hammersely family of New York and was built in memory of their daughter. The railroad brought religious diversity to the community of Ogden with the emigration of people from the east. The church membership of the Good Shepherd grew from 95 members in 1883 to 600 by 1915.

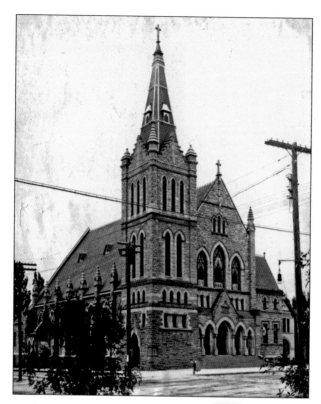

In 1902, Bishop Lawrence Scanlan dedicated St. Joseph's Catholic Church at its present site on Twenty-fourth Street and Adams Avenue. The church was designed to follow the true Gothic style. Fr. Patrick Cushnahan arrived in Ogden from Ireland in the fall of 1881. Under his guidance, the Catholic congregation in Ogden continued to grow. At first its members were mostly Italians, but in its later years, St. Joseph's has become a force in the Hispanic community.

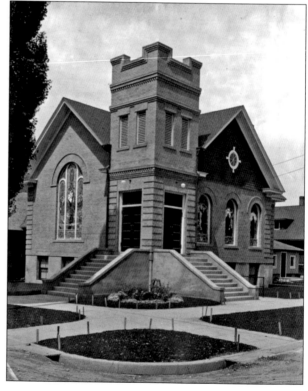

Situated on the southwest corner of Jefferson Avenue and Twenty-third Street, this building has been home to many different churches. In 1903, it housed the Swedish Evangelical Lutheran Church. The following year, the church had regular meetings in Swedish and English. By 1906, the building became known as St. Paul German Evangelical Church, with Rev. Herman Fleer as pastor. In 1929, the building was sold to the Ogden Japanese Christian Church.

The First Methodist Episcopal Church of Ogden was organized in 1870, with Rev. G. M. Pierce holding the first services at the Union and Central Pacific Railroad station. With membership increasing during the 1880s, a new church was erected on Twenty-fourth Street in 1890 at a cost of $65,000. The building served as the Methodist Church headquarters until 1925, when a new church was built on Twenty-sixth Street and Jefferson Avenue. The old church building on Twenty-fourth Street and Adams Avenue has now been converted into a nightclub. Kamikaze's offers local and national bands, along with the intriguing atmosphere of being in an old church building. (Bottom, courtesy of Jessica Johnson.)

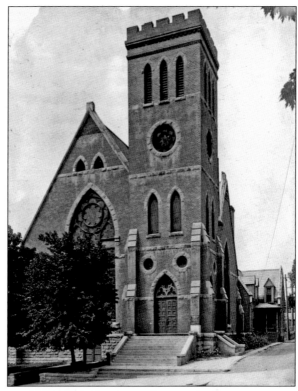

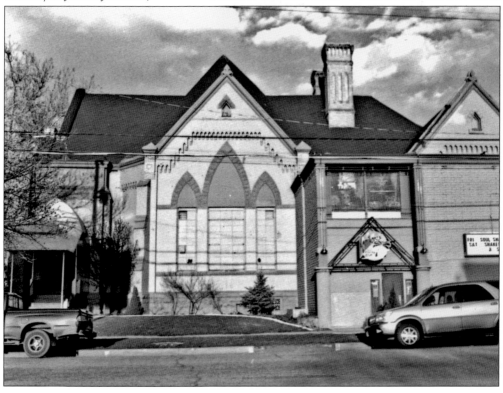

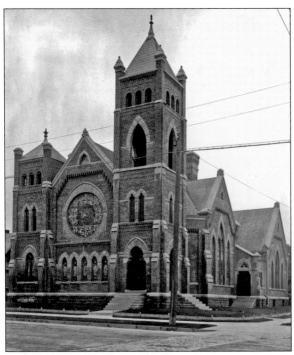

The Reverend G. W. Gallagher organized the First Presbyterian Church in Ogden on September 28, 1878, with a congregation of 20 people. The first church was built on Twenty-fourth Street and Lincoln Avenue in January 1880. The growing congregation moved to Twenty-fourth Street and Adams Avenue in 1906. This functioned as the meeting house until 1949, when they sold the property and moved to Twenty-eighth Street and Quincy Avenue.

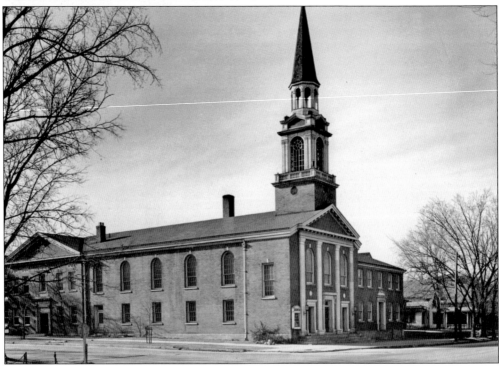

The Reverend Dwight Spencer arrived in Ogden in 1881 and established a Baptist presence. The First Baptist Church was built for $10,000 at Grant Avenue and Twenty-fifth Street. In 1915, with the church membership at more than 350, a new building was constructed at 2519 Jefferson Avenue. The building was dedicated in 1925 and continued in operation until 2008.

The Ogden Third Ward was established in 1856, when Ogden was divided into four wards by the Church of Jesus Christ of Latter-day Saints (LDS). Chauncey West was chosen as the first bishop of the ward. Prominent members of this branch of the LDS Church included the David Eccles family, the Farrs, and James Pingree. In 1930, the ward had 818 members.

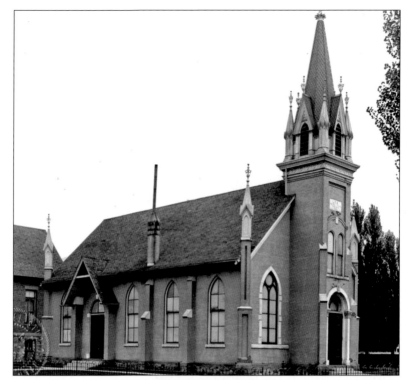

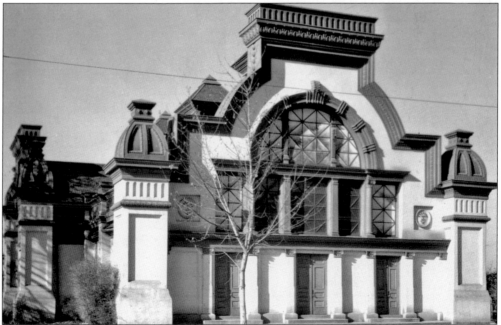

The original Ogden LDS Tabernacle was built from 1855 to 1869 by William Fife, who was paid $100 and some foodstuff for the building. The tabernacle was remodeled in 1896 at a cost of $15,000. The inside and outside were redecorated, with the foundation, walls, and roof unchanged. It also served as the second home of Weber Academy. The tabernacle was razed in the 1960s to make way for the Ogden Temple.

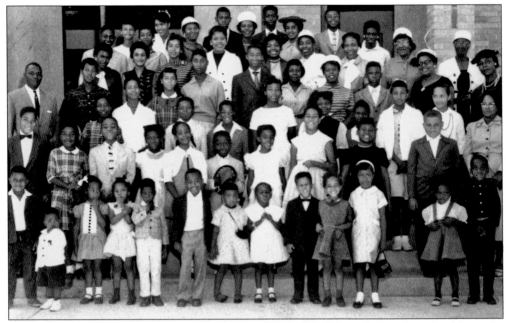

The New Zion Baptist Church is one of the significant churches in Ogden. It evolved from the Wall Avenue Baptist Church, which began in Ogden in 1918. By the 1950s, the congregation had grown so significantly that a new church was erected at 2935 Lincoln Avenue. The new building was dedicated in 1958. This photograph shows only a portion of the congregation in the 1960s.

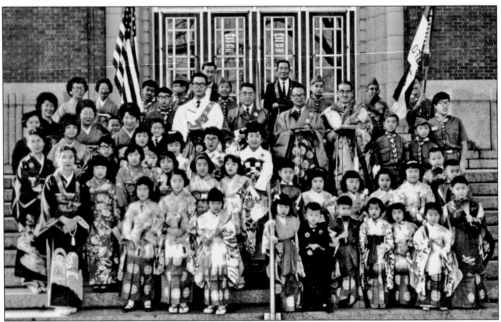

The Ogden Buddhist Temple was organized by Japanese citizens on March 1, 1913, at 236 Twenty-fourth Street. Members of the church gathered on the steps of the City and County Building in 1964 to mark the dedication of a new Buddhist church at 2456 Lincoln Avenue. Among those pictured are Rev. Akira Ono, Toki Yoshidi, Elsie Shiramizu, and Roy and Haruko Nakatani.

Four

FOR THE GOOD
OF THE YOUTH

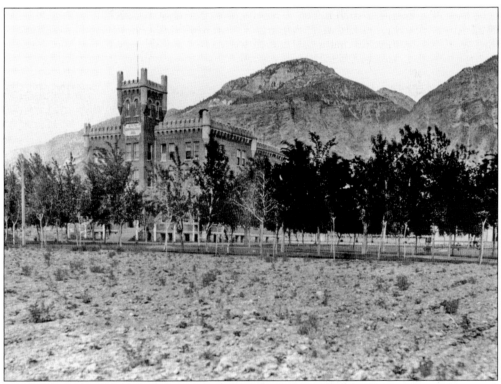

On October 1, 1889, the Ogden Military Academy opened with 70 resident students and 50 cadets. It was advertised as a "boarding school for boys and men strictly military in character." The school charged each cadet a fee of $750 per year to cover his schooling and room and board. The school had varied academic courses, some taught under the direction of U.S. Army officers. By 1897, the school became the State Industrial School.

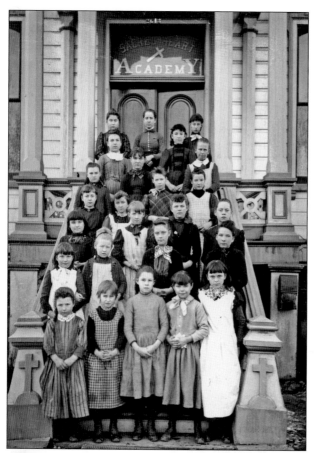

In 1878, the Sisters of the Holy Cross opened the doors to the Sacred Heart Academy on Twenty-sixth Street and Washington Boulevard. The original enrollment was 150 day students and 60 resident students. A group of seven sisters were sent from St. Mary's College to teach the students in courses of English, foreign languages, music, and art. By 1883, the student enrollment had grown to more than 200 day students in the three-story building. The school had such a high reputation that it drew students from all over the country. Enrollment in the school grew so quickly that, in 1892, the new Sacred Heart Academy was built on Twenty-fifth Street and Quincy Avenue.

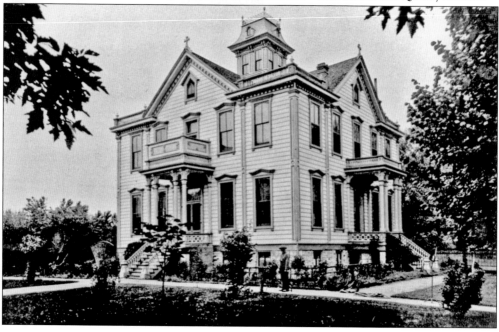

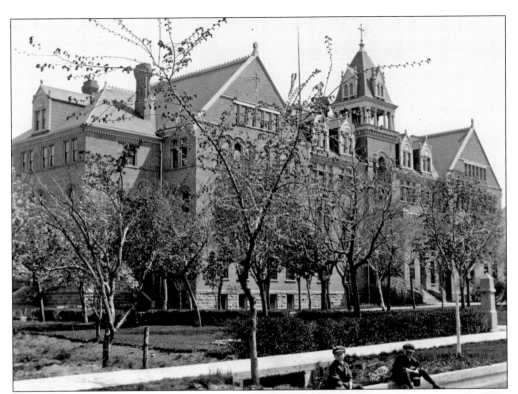

The land for the new Sacred Heart Academy was purchased in 1881 for $20,000, but it was another 10 years before the school could be built. St. Mary's College near South Bend, Indiana, paid for most of the construction of the school buildings. Sisters of the Holy Cross administered and did much of the teaching at Sacred Heart. The school opened in September 1892 and closed in June 1938.

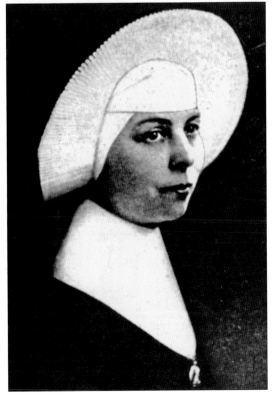

Sr. M. Madeleva CSC (born Mary Evaline Wollf) joined the Sisters of the Holy Cross in 1908 and became one of the order's best-known figures. From 1919 to 1926, she served as the principal of Ogden's Sacred Heart Academy before becoming president of the College of St. Mary-of-the-Wasatch in Salt Lake City. In 1934, she became president of St. Mary's College. Madeleva was also a prolific poet and essayist.

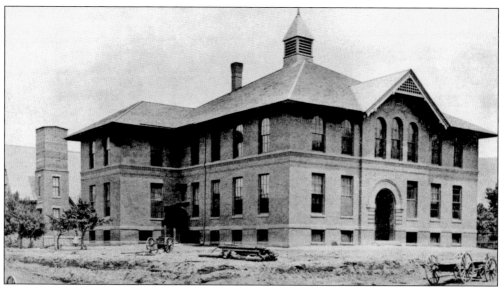

Under the direction of the Congregational Church, the Ogden Academy, located on Twenty-fifth Street and Adams Avenue, was built by the New West Education Commission in 1887. The school had a capacity of 600 students and taught primary, intermediate, and grammar grades and college preparatory. The goal of the founders was to provide intellectual, moral, and spiritual development under a Christian influence. The school was later sold to Ogden City and was used for public schools, including Ogden High School.

In the fall of 1896, the Utah School for the Deaf opened on Twentieth Street between Monroe and Jackson Avenues. The law required that all deaf students from the age of 8 to 18 attend. The aim of the school was "to develop self-respecting, self-supporting individuals who, in spite of their handicaps, can sustain themselves in ordinary society." They were schooled in domestic science, physical culture, and manual training.

In 1892–1893, the voters of Ogden voted on two bonds to rebuild some of the public schools to meet the needs of the growing enrollment. Grant School was one that saw a dramatic remodel. At the cost of $32,000, Grant School was built after the model of the Madison School on Grant Avenue between Twenty-second and Twenty-third Streets. Very little alterations were ever made to the building.

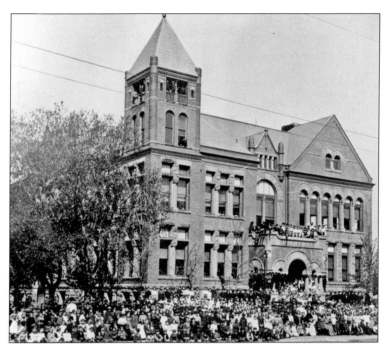

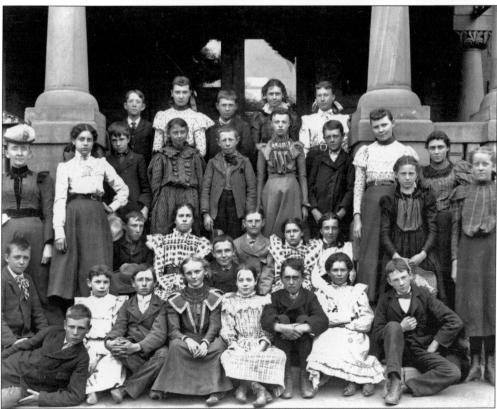

Pictured is a class of students around the turn of the 20th century. Two students are identified as Della Shipley (first row, fifth from the left) and Thora Williams (sitting next to her).

On September 26, 1880, the city of Ogden dedicated the Central School. Built on Twenty-Fifth Street and Grant Avenue, it was the "show school" of Ogden for many years. The school ushered in a new era for the public school system in Ogden. In 1911, the city sold it to the Order of the Elks to serve as their lodge.

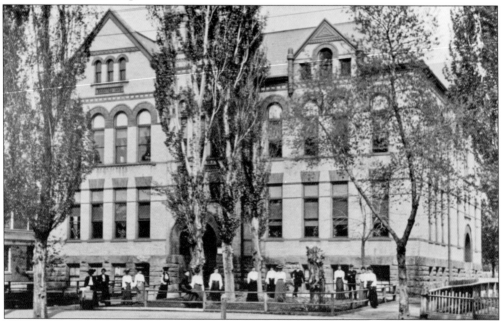

In 1892, the Madison School was erected at the site of the previous Lester Park School on Madison Avenue between Twenty-fourth and Twenty-fifth Streets. At a cost of just over $32,000 to build, the school was often referred to as "the most beautiful and commodious building in the city." The school originally had eight rooms, with six more added in 1907. Classes included students from kindergarten to eighth grade.

In 1890, the Five Point School District became part of Ogden City. The city voted to build a bigger school for the elementary students in that area on Third Street and Adams Avenue. The new school building cost $16,770. The school grew from three teachers to eight by 1905. In 1919, W. Karl Hopkins, superintendent of schools, renamed Five Point School Lincoln in honor of Pres. Abraham Lincoln.

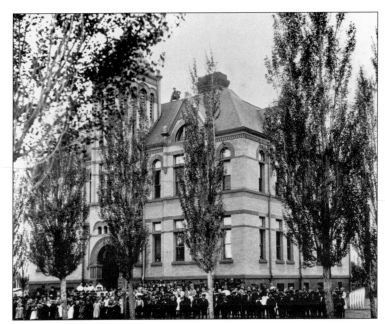

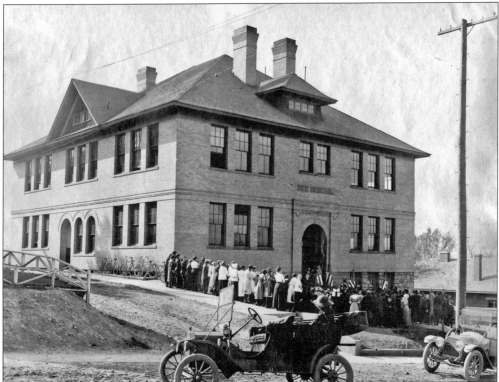

In 1904, the Ogden City School Board decided to build a new elementary school on Twentieth Street and Ogden Avenue to alleviate overcrowding at other schools. The school was named the Dee School after Judge Thomas D. Dee, who was board president and was active in the Ogden schools. The 10-room structure housed elementary school children until 1912–1913, when it became a junior high school.

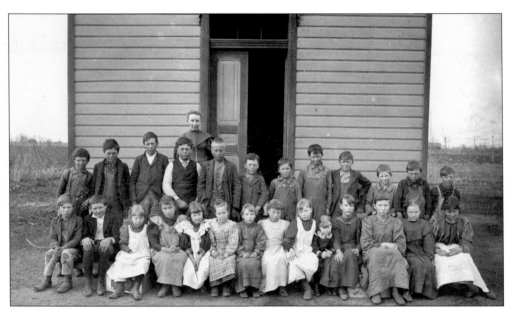

The Broom's Bench School was finished in 1890 with one room, four windows, two doors, and a solid blackboard at the back. The school was opened in January 1891 by Linda Irwin, who had moved west from New York because of her health. Irwin became an important teacher in the Ogden schools, serving in the Broom's Bench District, which included the Washington and Grant Schools, for over eight years. She frequently walked the four miles from her home on Thirty-sixth Street and Kiesel Avenue to her school when the railcars could not drive through the snowdrifts. She lived to be over 87 years old and served Ogden as an educator to many students during her career.

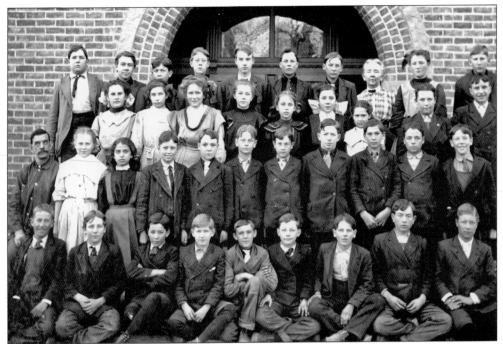

The Washington School started in Ogden in 1873 as a one-room building that contained 37 double desks. The school was not used for a year, at which time it was discovered that the building was too unsafe for occupancy. It took the citizens of the area time to raise the additional $500 needed to fix the school. Once opened, the school continued to grow in space and students. By 1914, the building, located on Madison Avenue between Twenty-fourth and Twenty-fifth Streets, had 14 rooms to teach the elementary and growing junior high populations. Linda Irwin is pictured here with two of her classes outside the 1886 brick addition to the building.

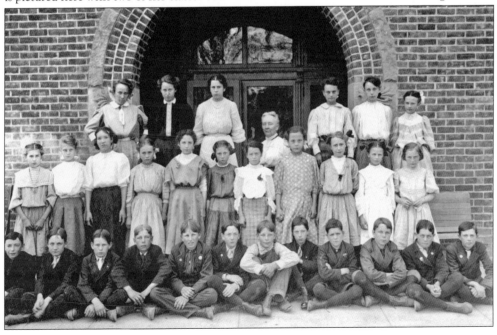

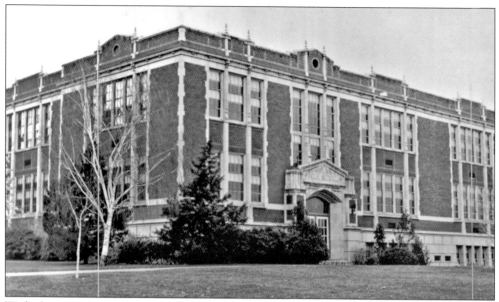

With the growing population of Ogden going eastward toward the mountains, the Ogden City School Board contracted with Leslie Hodgson to design a school building at Twenty-sixth Street and Polk Avenue in 1926. For the cost of $68,000 and with a construction time of less than a year, Polk School was built. The school taught grades three through eight and had an active curriculum.

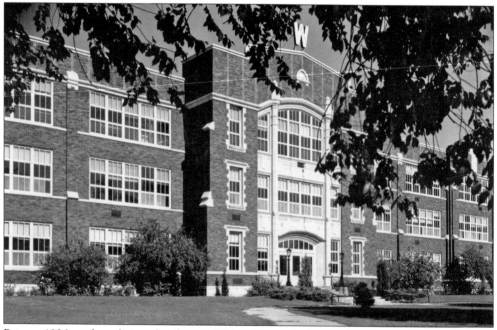

Prior to 1926, students living elsewhere in Weber County had to pay $40 a year in tuition to attend Ogden High School. A $300,000 bond issue was approved 733-480 by voters to build a new high school. Weber County High School at 1100 Washington Boulevard was built to accommodate the growing rural population of Ogden. Even though it was still under construction, classes where held at the school starting in the 1926–1927 school year.

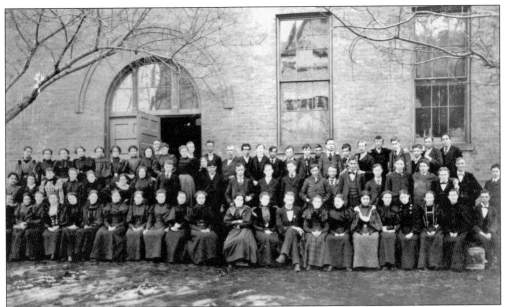

Ogden High School began in 1890 using the upper floor of city hall as the classroom, with the first graduating class consisting of seven young girls. In 1896, the school board leased the building on Twenty-fifth Street and Adams Avenue that was owned by the New West Educational Society. By 1898, a total of 185 high school students were enrolled. Pictured here is the graduating class of 1899.

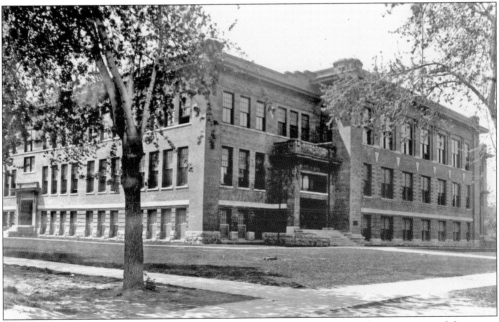

The enrollment at Ogden High School had grown such that by 1909, there was a need for a new building. Fred J. Kiesel donated the land at Twenty-fifth Street and Monroe Avenue for the new school. At a cost of $100,000, Leslie Hodgson and the Eccles Lumber Company constructed the building. The school became Central Junior High after the new million-dollar Ogden High School building was completed in 1936.

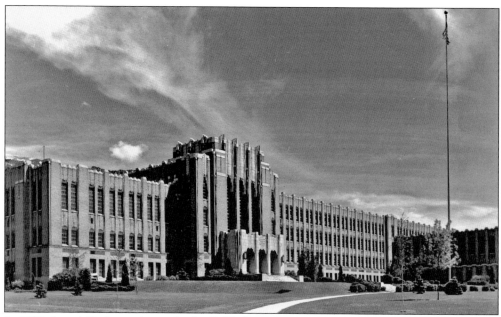

In 1936, famed Ogden architect Leslie S. Hodgson designed Ogden High School on Harrison Boulevard and Twenty-eighth Street. It was built by the Works Progress Administration. The building was Utah's first million-dollar high school and was ranked among the foremost buildings of its type in the United States for its architectural beauty. The school has a capacity of 1,700 students and graduates about 600 per year.

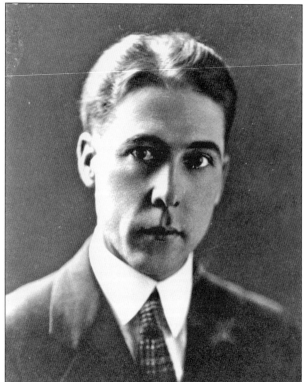

Leslie S. Hodgson came to Ogden in 1906 after studying architecture under students of Frank Lloyd Wright. During his 40-year career, he designed more than 75 buildings and schools. Although he designed in Wright's prairie style and several period-revival styles, Hodgson was best known for his art deco public buildings and homes. Many of his buildings still stand today, such as Ogden High School, the City and County Building, and the Egyptian Theater.

Located on the west side of Jefferson Avenue between Twenty-fourth and Twenty-fifth Streets, the Moench Building—shown in a late-1920s photograph—was the heart of Weber's downtown campus. It was named for Louis F. Moench, Weber's first principal, serving in 1889–1892 and 1894–1902. Originally constructed in 1891, with an important addition built in 1907, the building included classrooms and administrative offices. Deeded back to the LDS Church in the mid-1960s, it was razed in 1970.

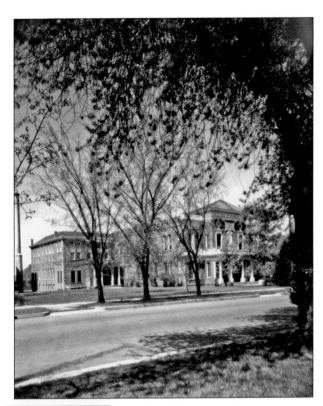

David O. McKay was born outside Ogden in 1873. He served as an educator and Weber's principal from 1899 to 1906, when he was called as an apostle in the Church of Jesus Christ of Latter-day Saints. He still kept ties in Ogden by helping to transfer Weber to the state in the 1930s, and the McKay-Dee Hospital was named after him in the 1960s.

Lydia H. Tanner (in the white coat) is shown receiving meat and produce to be used in the school's cafeteria. In-kind donations in lieu of tuition, and a college bus that picked up students throughout Weber County, characterized the difficult days of the Great Depression. Still under the control of the LDS Church, Weber saw both appropriations and salaries decline, though enrollments grew. Weber became a state-sponsored school in 1933.

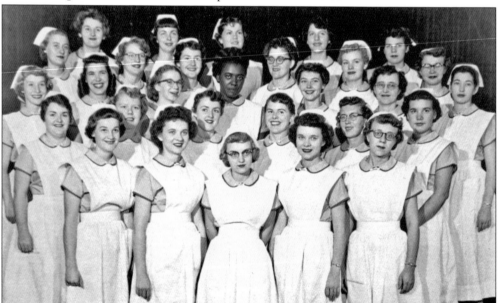

Since the early 1950s, Weber has always been noted for a strong and successful nursing program. In the beginning, the students worked closely with the medical staff of St. Benedict's and Dee Memorial Hospitals, whose own nursing programs were eventually taken over by Weber. This photograph is of Weber's first graduating class of 29 registered nurses in 1955. Today the university graduates some 200 RNs annually.

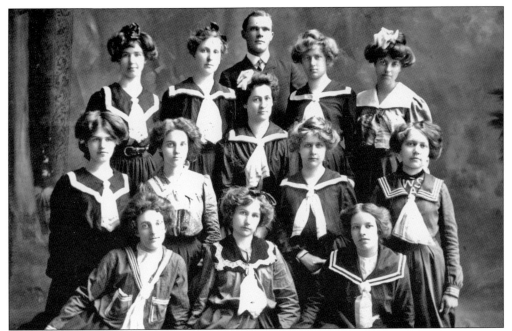

Women's sports started early at Weber. Pictured here is the 1902 basketball team. The *Ogden Standard* reported that the team defeated the women's team from Brigham Young Academy by a score of 9-7. The next year, the Weber Academy women won the state championship with a record of six wins and two losses. Despite this success, the program was discontinued after the 1904–1905 season, not to return until the 1970s.

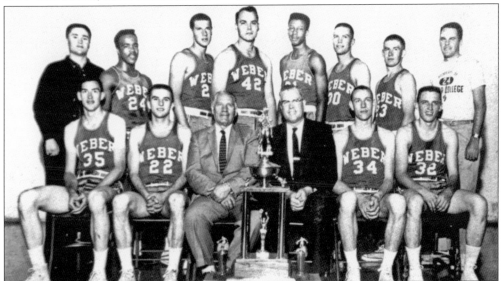

Weber College's 1959 basketball team, under the direction of coach Bruce Larson (standing, far right), won the 1959 National Junior College championship. The team, shown here with athletic director Reed Swenson and Pres. William Miller (center, wearing suits), also included Allen Holmes, the tournament's Most Valuable Player, who averaged 28.8 points per game. Holmes (second row, fifth from left), an All-Conference player in 1958 and 1959, was elected to Weber State's Athletic Hall of Fame in 1989.

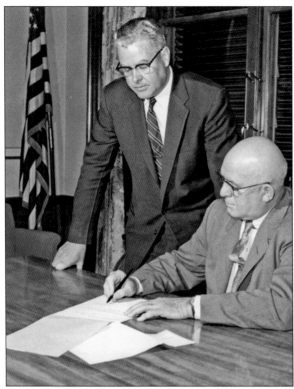

William P. Miller, who served as Weber State's president for 20 years, watches as Utah governor George D. Clyde signs the legislation giving the school four-year status. The bill was signed in 1959, and the graduating class of 1964 consisted of 265 four-year degrees out of a total of 447 degrees awarded. This change in status marked the beginning of dramatic enrollment growth at the school.

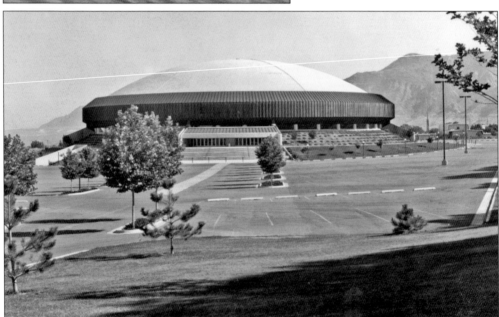

The Dee Events Center was dedicated in November 1977. Constructed as a public/private partnership, the building memorializes the common ancestry of the donors through the publicly minded Thomas D. Dee family. A Northern Utah landmark, with a total capacity of 25,000 seats, the Dee Events Center not only serves as the home of Weber State's men's and women's basketball teams, but also as an important venue for entertainment, civic, and educational events.

Five

BRIGHT MEN AND WOMEN IN A LIVELY TOWN

Lorin Farr arrived in Ogden in January 1850 after Brigham Young asked him to take charge of events in Ogden. He was the first mayor of Ogden and served in that capacity for 20 years without pay. He was responsible for all of the early irrigation projects in Weber County. He built the first sawmill and gristmill in Weber County in 1850, powered by the water diverted from the Ogden River.

Fred J. Kiesel became the first non-Mormon mayor of Ogden in 1889. It was on his third run for mayor that he finally won on the Liberal Party ticket. He vehemently opposed the union of church and state under the Mormon People's Party. Kiesel defeated his opponent, John Boyle, by 391 votes. The next morning, the local paper ran the headline, "OGDEN AMERICANIZED."

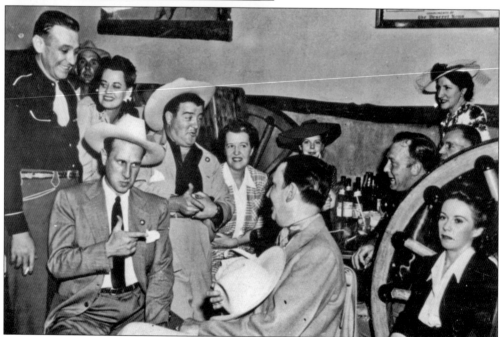

Harmon W. Peery served as the Ogden City mayor in 1934–1939, 1942–1943, and 1948–1949. He was known as the flamboyant "Cowboy Mayor" and used the Pioneer Days Rodeo to draw attention to Ogden. The rodeo attracted national acts like Abbott and Costello, shown here in this photograph with Harmon Peery (holding the hat) at Ogden's Old Mill. Peery was responsible for bringing national attention to Ogden.

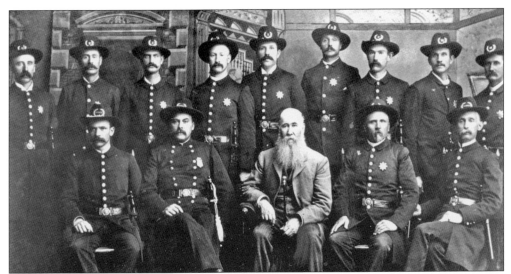

Robberies and violence of all sorts were problems in Ogden City. Pictured here is the Ogden police force in 1891. Identified in the photograph is city judge S. M. Preshaw (seated in the center with the beard). Seated second from left is police chief John W. Metcalf. Seated fourth from left is officer William Brown, who was killed in 1899 while assisting in the apprehension of two robbery suspects in Willard, Utah.

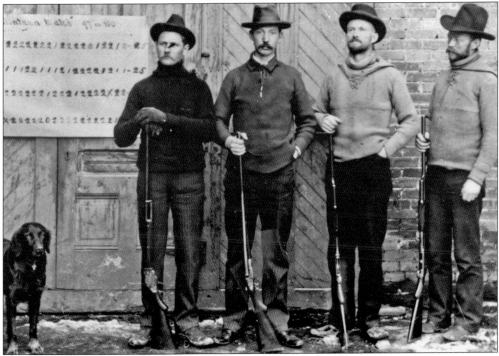

Shooting galleries and gun clubs were popular in Ogden during the late 19th and early 20th centuries. Some of the most prominent men of Ogden engaged in the sport. Shown from left to right in this photograph are Gus Becker, owner of Becker Brewing, and Archie Bigelow, owner of the Bigelow Hotel on Twenty-fifth Street and Washington Boulevard. Their shooting partners were brothers and famous gun makers John M. Browning and Matt Browning.

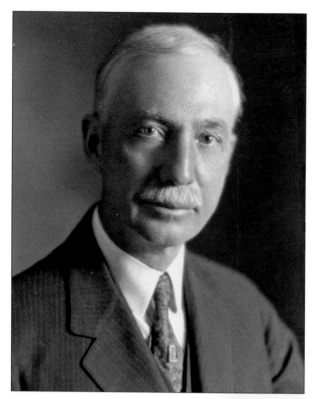

Archie P. Bigelow was a prominent and respected businessman in Ogden. He was the owner of the Bigelow Hotel, known as one of Ogden's finest hotels in the 1920s, and was also the president of the Ogden State Bank. When the Depression hit the United States, Ogden State Bank failed, leaving Bigelow completely broke. He immediately left for California, where he never quite recovered from the loss.

The Belnap family was one of the most prominent families in Ogden. Gilbert Belnap, the patriarch, was one of Weber County's first sheriffs. He had two wives and 17 children. Pictured here are some of the Belnap children and grandchildren, taken outside the family home at 2155 Madison in 1908. Shown from left to right are Olive, Marion, Laura, Flora, Walter A. Kerr, Christiana, and Hyrum Belnap.

As a Scottish immigrant, David Eccles and his family arrived in Utah in 1863, when he was just 14. Although he lacked any formal education, he worked hard and amassed a fortune based in the lumber industry. He formed 27 corporations and served as president of 17 of them, including the First Security Bank and the Utah Construction Company. By the time he died in 1912 of a heart attack, he was one of Ogden's wealthiest men.

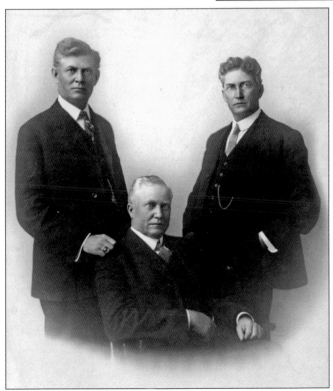

The Wattis brothers—Edmund O. (standing on left), William H. (seated), and Warren L.—joined forces with other prominent Ogden men to found the Utah Construction Company in 1900. The company was responsible for construction projects such as the Western Pacific Railroad, Hoover Dam, and mines worldwide. The company was sold in 1976 to General Electric by the grandchildren of the founding members as the largest merger of its kind in U.S. history.

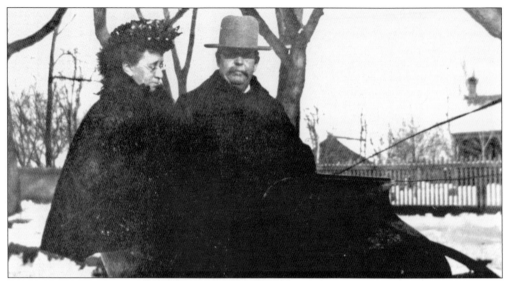

Thomas D. and Annie Taylor Dee were among Ogden's elite during the first part of the 1900s. Thomas was employed as an attorney, judge, vice president of the First National Bank of Ogden, and president of the Utah Construction Company. He met an untimely death when he fell into the Ogden River in 1905 and died of pneumonia. Annie turned his death into something positive for Ogden by creating the Dee Memorial Hospital.

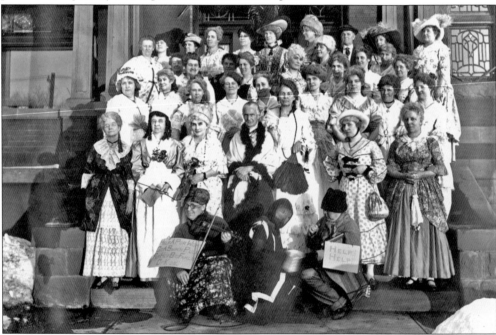

The Child Culture Club was founded in 1898 for the mutual benefit of its members in the study of child development, hygiene, U.S. history, and art. They started a dental clinic, raised money for a swimming pool, and aided the Red Cross during both world wars. Members are pictured here outside the home of Martha Wattis (second row, second from right)in February 1915. Other members included Bertha Eccles (second row, far left) and Annie Dee (second row, second from left).

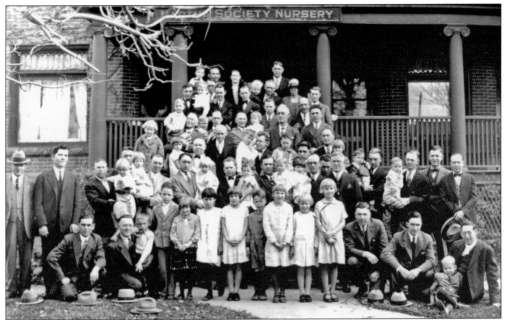

The Martha Society was established in Ogden in 1906 by a group of well-to-do women for charitable work among Ogden's poor and needy. One of the major accomplishments of the society was the creation of the Martha Society Nursery, located on the corner of 300 North Washington Boulevard. The nursery provided a safe place for working mothers to drop off their children during the day. Pictured here are the nursery children during the 1920s.

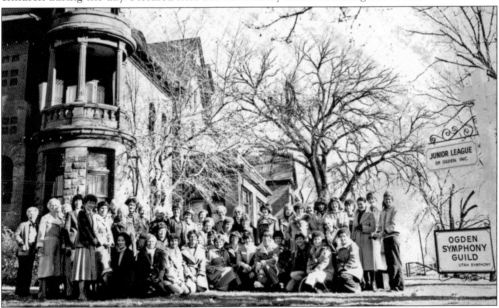

The Junior League of Ogden grew out of the Martha Society and the Welfare League in 1934. The league was responsible for the well-baby, dental, and immunization clinics, and for the sponsorship of children's plays and puppet shows. During World War II, the league supported the war effort and the Red Cross. Pictured here are the members of the Junior League outside their headquarters during the 1980s.

Born in Ogden in 1897, Bernard De Voto had a distinguished career as a historian, critic, and commentator, receiving several prestigious awards, including the Pulitzer Prize and the National Book Award. He was also well known for his *Harper's* column "The Easy Chair." Though he had deep Ogden roots, his 1926 *American Mercury* article entitled "Utah" angered many local residents when he stated that "civilized life" did not and would never exist in the state. In later years, he admitted his youthful views were "brash" and "irresponsible." (Special Collections Department, J. Willard Marriott Library, University of Utah.)

Fawn McKay Brodie, first a student, then a faculty member at Weber College in the 1930s, is shown here in a stylized shot as a 16-year-old freshman in 1931. Her controversial 1945 biography of Joseph Smith, *No Man Knows My History*, led to her excommunication from the Mormon faith. In later years, she taught at the University of California, Los Angeles (UCLA) and was an award-winning biographer of Thomas Jefferson and Richard Nixon.

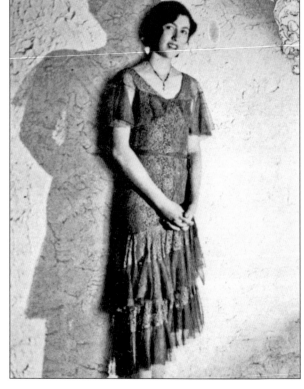

Loring "Red" Nichols was born in Ogden in 1905. His father, Ernest, a music instructor at Weber Academy, started teaching Red the violin and trumpet at age three. He played in marching bands and in shows with his father. At the age of 19, Red left Ogden and went to New York City to try his hand at the growing jazz scene. He signed to a record company in 1926 and continued to make music until his death in 1965. The right photograph, showing Red at the tender age of five playing the bugle, was a gift to his kindergarten teacher, Marian Kerr. Below is one of the many studio shots taken of Red for the Columbia Broadcasting System to promote an album or event.

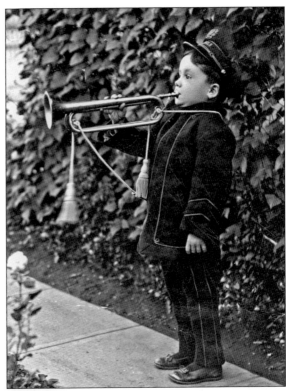

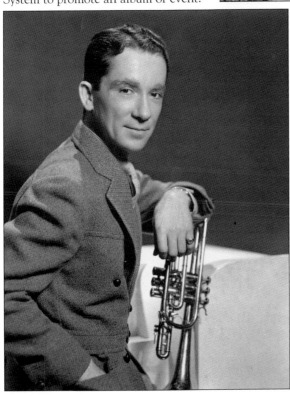

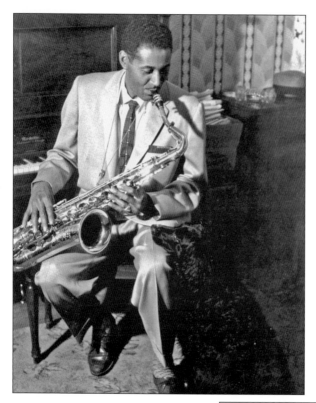

Born in Dallas and raised in Ardmore, Oklahoma, Joe McQueen was mentored on the saxophone by his cousin, Herschel Evans, who played with Count Basie. Playing professionally since the age of 16, McQueen has been a presence on Ogden's Twenty-fifth Street jazz scene since the 1940s. Despite rubbing shoulders with such jazz greats as Charlie Parker and Lester Young, McQueen also maintained a day job as an automotive technology instructor at Weber State in the 1970s.

Al Warden came to Ogden in 1919 to work as a reporter for the *Ogden Standard*. During his time in Ogden, he promoted various sports events from the 1920s to the 1950s. Some of the events he worked with were the ski races at Becker Hill and Snow Basin, and the winter sports events. He helped organize the Pioneer Baseball League and brought famous athletes to Ogden, including Jack Dempsey.

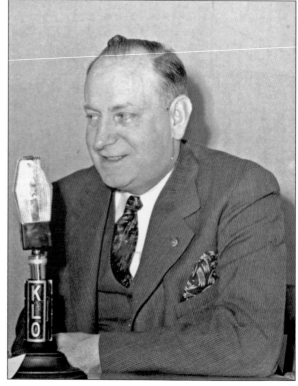

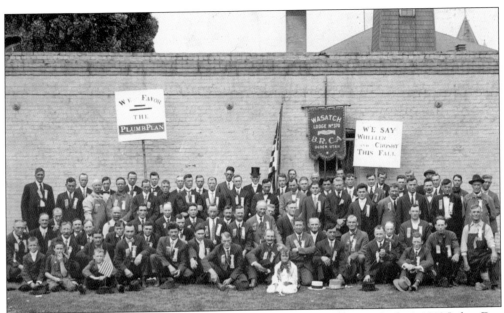

Railway car men local No. 370 members and several children gather at Ogden's 1919 Labor Day festivities. The sign on the left proclaims support for the Plumb Plan, a proposal authored by Glenn Plumb, counsel for railroad employees, calling for public ownership of the railroads to replace the government's wartime Railway Administration. The other urges support of union-backed candidates Durlin Wheeler and George Crosby in the upcoming municipal elections. The ticket finished in third place.

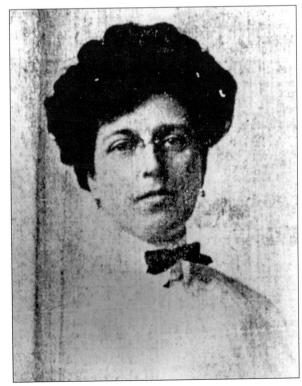

Dora Topham, also known as Belle London, was Ogden's most notorious madam during the early 1900s. She owned and operated several brothels on Twenty-fifth Street and Electric Alley, and became wealthy enough that she could give thousands of dollars worth of food and clothing to the poor. Belle owned the London Ice Cream Parlor on Twenty-fifth Street and used the business as a front for her brothel on the second floor of the building. (Used by permission, Utah State Historical Society, all rights reserved.)

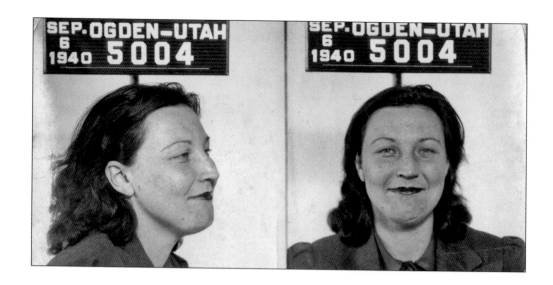

From 1875 to 1950, Twenty-fifth Street in Ogden was known as "two-bit street" and was notorious for saloons, opium dens, prostitution, gambling, and violence. The prostitutes worked out of Electric Alley or in rooms run by madams. During World War II, the railroads stopping in Ogden brought a constant stream of young soldiers looking for female companionship. Here are mug shots of two prostitutes arrested in 1940 in the Dixie Rooms, Kay Martin (above) and Frances Meyers (below). According to a newspaper article, girls during that time were likely to charge $2. By 1955, the sheriff's office had driven the vices from open view on Twenty-fifth Street and put many of the houses of prostitution out of business.

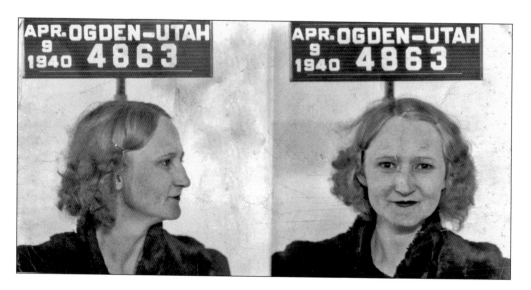

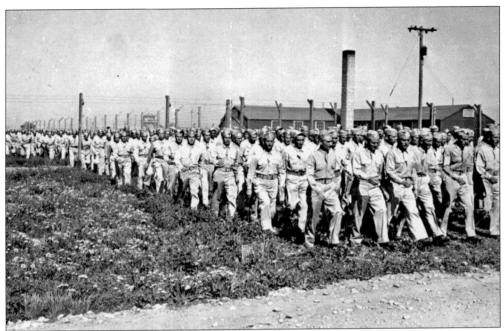

During World War II, approximately 7,000 Italian and German prisoners of war were housed at camps in Ogden. The Ogden General Depot, later known as the Defense Depot Ogden (DDO), was the major encampment for the prisoners. When the Italians surrendered to the United States, the prisoners were given the opportunity to work as farm laborers, in production, in construction, and in canning factories to support the war effort. Pictured above is the daily regimental review of the Italian Service Units. Below is a photograph of German prisoners of war working in the canning factory at DDO. The workers got paid about 90¢ for a full eight-hour day and were able to use it at the commissary shops on the depot grounds.

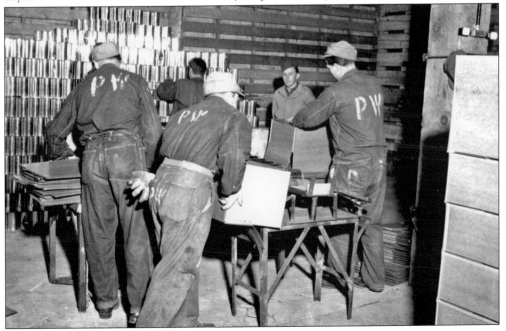

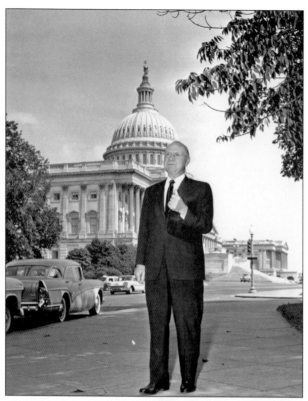

Henry Aldous Dixon served as president of Weber College from 1919 to 1920 and from 1937 to 1953. He was responsible for the move of Weber College to its present home on Harrison Boulevard in the 1950s. He was elected to Congress in 1955 and served until 1961. He is pictured at left in Washington, D.C., with the U.S. Capitol in the background. During his time in Washington, Dixon (below, third from left) was able to collaborate with other important political figures from Ogden, such as (from left to right) Laurence J. Burton, a fellow U.S. representative who served Utah from 1963 to 1971; J. Willard Marriott, founder of the Marriott Corporation and Marriott Hotels; and Mark Evans Austad, an ambassador to Finland and Norway, pictured below.

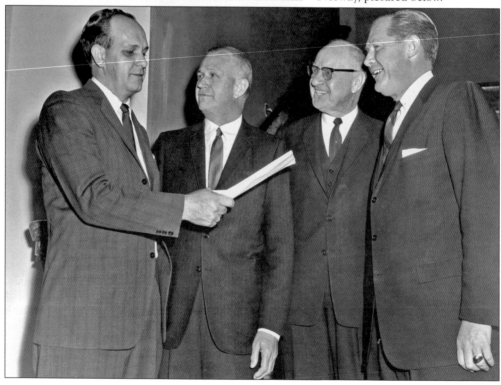

Six

A BUSTLING TOWN OF MERCHANTS AND BUILDINGS

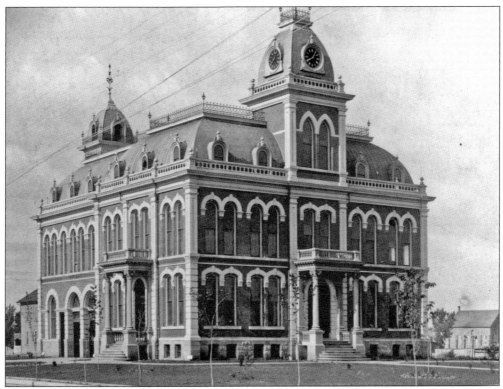

In 1888–1889, Ogden City constructed a city hall on Washington Boulevard near Twenty-fifth Street. William Fife, one of Ogden's noted architects at the time, designed the building. The building was made from stone quarried at Thistle in Spanish Fork Canyon and had a clock and bell tower at the top. City hall stood until it was demolished in 1942 to make room for the new Ogden City Municipal Building.

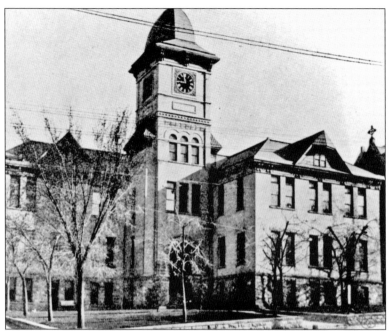

The Weber County Courthouse was built in 1876 on Twenty-fourth Street between Washington Boulevard and Adams Avenue. This two-story building served as the county courthouse and jail until it was destroyed by fire in 1895. It was rebuilt and served the county until 1940, when the offices moved to the new City and County Building.

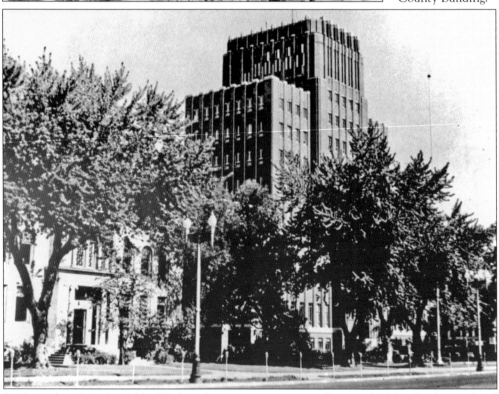

In November 1940, the Public Works Administration, as part of Roosevelt's New Deal, completed the construction project of the City and County Building for Ogden City. The building was designed by well-known Ogden architect Leslie Hodgson. The 12-story building housed the city and county offices. The building still stands at 2549 Washington Boulevard.

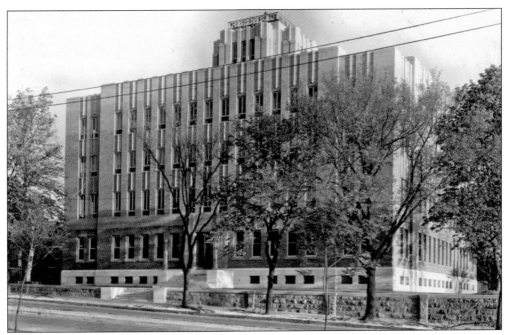

Another Public Works Administration and Leslie Hodgson joint project was the U.S. Forest Service building. Located at Twenty-fifth Street and Adams Avenue, it was built in 1933. Since 1908, the Ogden office has been the headquarters of District Four of the forest service, which encompasses the territory of the Intermountain states.

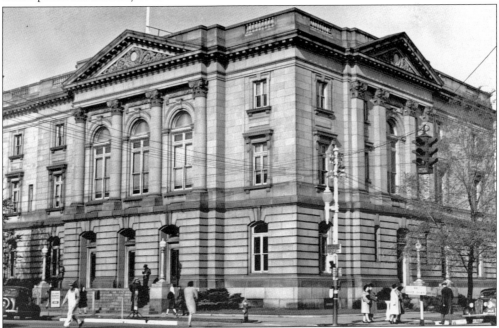

The main post office building for Ogden was located at Grant Avenue and Twenty-fourth Street. The original building was completed in 1908, with an addition made in 1915. The Greek Revival–style building served as the post office and federal offices for Ogden until 1974. It is now a private business building.

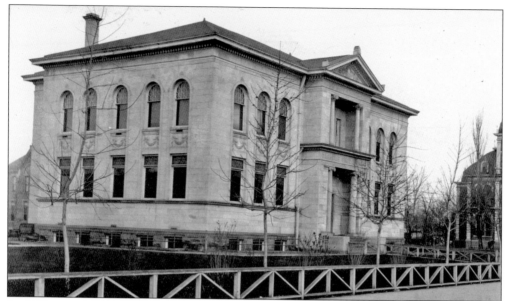

In 1901, a committee of the Ogden Literary and Debating Society Library Association corresponded with Andrew Carnegie and received $25,000 for the building of a public library. The Carnegie Free Library opened in 1903 with 3,000 new books. The library served the public of Ogden until the 1970s, when it was replaced with the Weber County Library and the building was torn down.

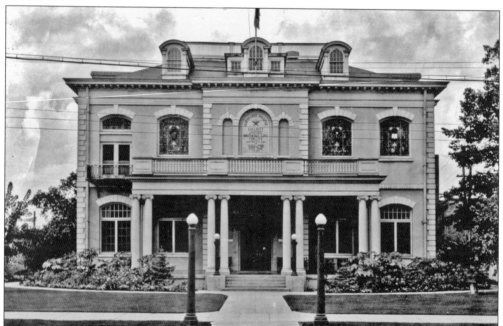

Ogden's Benevolent and Protective Order of Elks (BPOE) Lodge No. 710 was founded in 1901. It was located on Washington Boulevard until 1912, when the lodge relocated to the former Central School on the southwest corner of Twenty-fifth Street and Grant Avenue. The Elks stayed in this downtown location until the mid-1990s, when they moved to the suburban community of Roy.

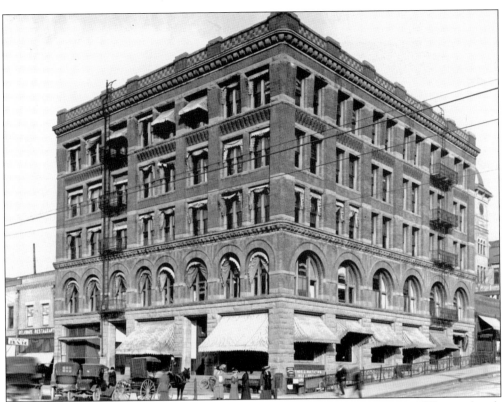

The First National Bank building was constructed in the 1880s at the corner of Twenty-fourth Street and Washington Boulevard. The building housed offices for Thomas Mathews, real estate; W. Clark, a dentist; and Dr. Robert Joyce. Dr. Joyce was the family physician for the Thomas D. Dee family and became the first doctor at the Dee Memorial Hospital. Next to the First National Bank building was the Utah Bar and Delaware Restaurant.

On the corner opposite the First National Bank Building is the Eccles Building. The building was named after early Ogden entrepreneur David Eccles. Housed within the Eccles Building was the Fred M. Nye clothing company. Nye sold "reliable work clothes for the hard working men." The building also provided office space for doctors and dentists.

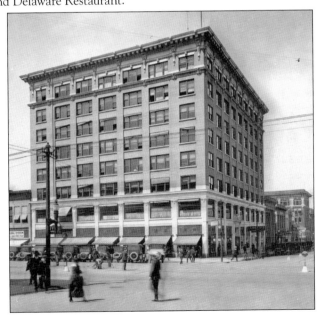

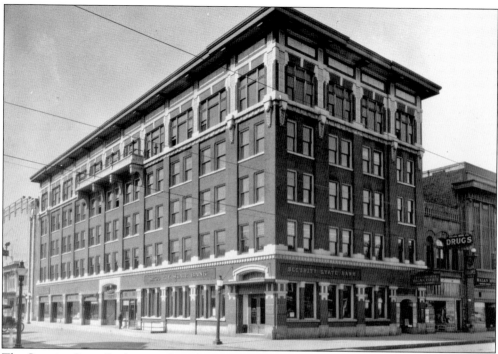

The Security State Bank opened in the Kiesel Building on the corner of Twenty-fourth Street and Kiesel Avenue in 1914. Timothy D. Ryan was listed as president of the bank and Fred J. Vicks as the cashier. The bank folded in 1925. Situated next to the Alhambra Theater, the Kiesel Building housed many businesses, including mortgage companies, lawyers, Kammeyer's Bike Shop, and the Goshen Studio, a major Ogden area photographer.

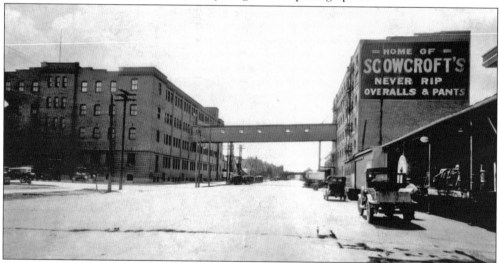

Between 1900 and 1904, John Scowcroft and his sons built the John A. Scowcroft and Sons warehouse at Twenty-third Street and Wall Avenue. The building housed their wholesale groceries, dry goods, clothing, and overall manufacture. A total of 11 wholesale businesses were housed in this warehouse. Scowcroft was known for their "Never Rip Overalls." By 1909, they were making 2,000 overalls a day. During the 1920s, the grocery businesses became American Food Stores.

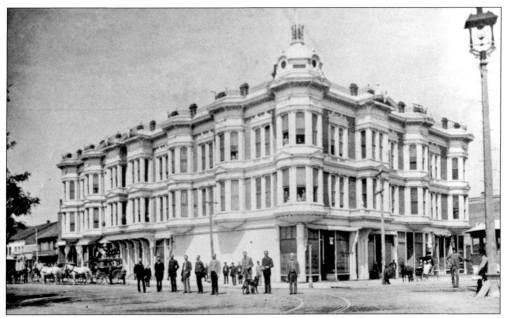

The Broom Hotel opened for business in 1883. It was constructed by John Broom, who recognized that Ogden lacked the proper hotel accommodations for tourists and businessmen. The hotel stood on the corner of Twenty-fifth Street and Washington Boulevard. This photograph shows John Broom (center) and his friends and family outside his elegant hotel.

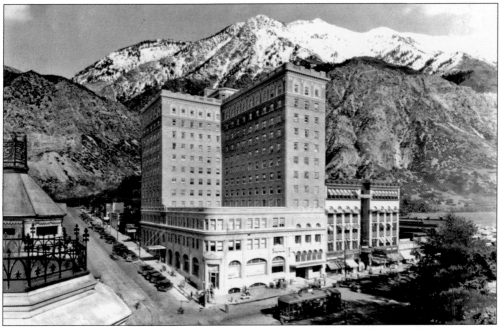

In 1926, A. P. Bigelow began construction on Ogden's newest hotel, Hotel Bigelow, on the site of the old Reed Hotel at the corner of Twenty-fifth Street and Washington Boulevard. It was completed in 1927 and quickly became one of Ogden's finest hotels, having been built in the Italian Renaissance style. In 1933, Marriner Eccles purchased the hotel and renamed it the Ben Lomond Hotel.

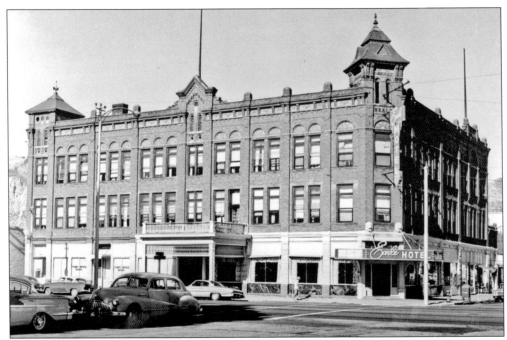

Standing on the corner of Twenty-fifth Street and Wall Avenue, the Healy Hotel was built in 1901. It opened its doors on September 1, 1901, welcoming visitors to a fine hotel with furniture built by the Boyle Furniture Company. It was one of the major tourist stops because it sat directly across the street from the Union Station. Its name was later changed to the Earle Hotel before it was torn down in 1946. (Courtesy of John Shupe.)

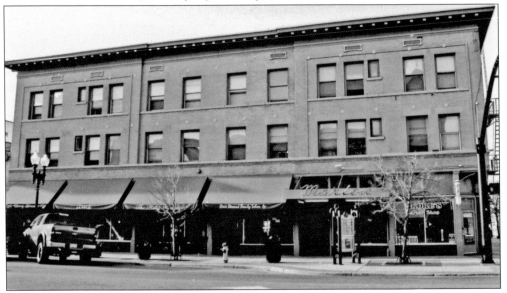

Opened in 1911, the 150-room Marion Hotel featured rooms with or without baths. It still stands at the corner of Twenty-fifth Street and Lincoln Avenue. In recent years, the three-story building has been a low-cost single-residence occupancy and, in the 1980s, housed the Homeless Veterans Fellowship. Over the years, a number of retail shops and taverns have occupied the first floor. Today it is the home of Moore's Barbershop. (Courtesy of Jessica Johnson.)

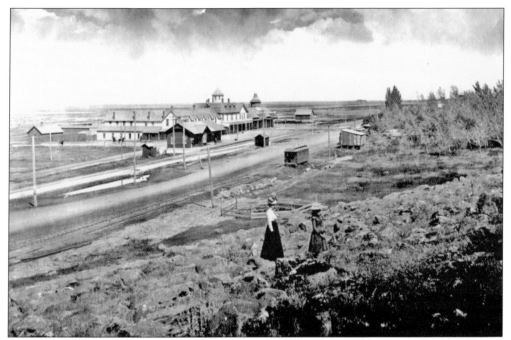

The Utah Hot Springs, at the north end of Ogden, was built in 1880 by Ranson Slater. It was known for its mineral baths and racetrack for bicycle racing. It had a hotel with 21 rooms and a dining facility, and the resort was connected to Ogden by a railroad line. It was touted by the local newspaper as a place to restore ill people back to health by visiting the curing waters.

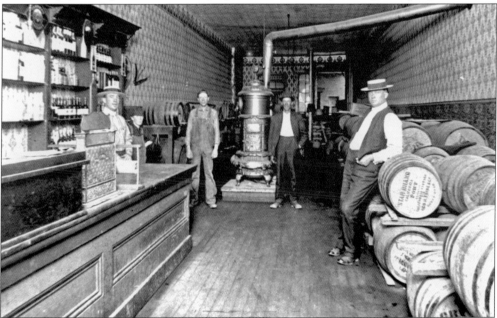

George H. Tribe owned and operated a liquor store on Twenty-fourth Street and Washington Boulevard. This picture is the inside of the wholesale and retail store, taken between 1911 and 1913. Pictured are, from left to right, Arthur G. Tribe, clerk; unidentified boy; Alonso Hadley, driver; unidentified man; and John M. Hansen, salesman, standing next to the barrels.

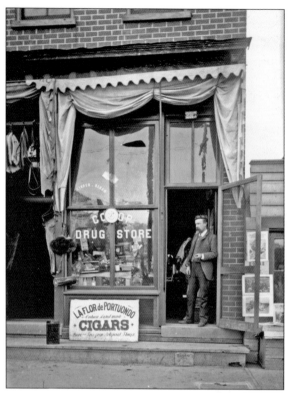

Despite this photograph showing the storefront for the Ogden Co-operative Drug Store, the building was the Bank Smokery. George Cave owned the co-op store from the early 1900s to the 1930s at 2301 Washington Boulevard, and the Bank Smokery was at 2315 Washington. In 1913, Howard Goddard opened the store with his son, Harold. The store sold cigars, tobacco, pipes, magazines, candy, and soda fountain drinks.

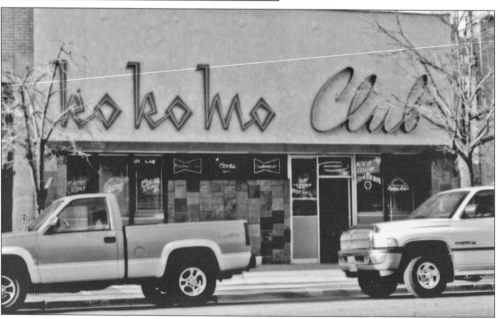

Originally known as the Pioneer Tavern, the Kokomo Club has been a Twenty-fifth Street landmark since it changed names in the late 1940s. Not long after that, Jack Kerouac wrote in *Visions of Cody*, "Then Ogden, which I dug, Jap hipsters, crazy bum street with Kokomo Bar at foot of which white-capped mountains rise—a town I heard about some, I can see it's something." (Courtesy of Jessica Johnson.)

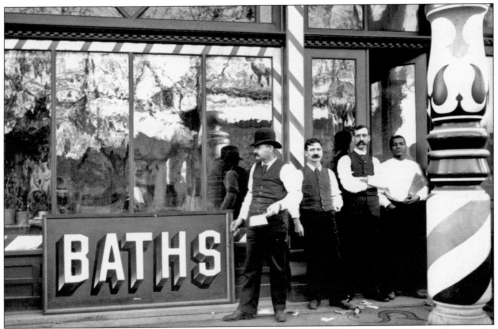

In Ogden, a major railroad stop in the West, tourists would often get off the train looking for a bath and a close shave. Barbershops like this one at 2460 Wall Avenue were located all over the downtown area. This shop was owned by N. R. Shaw and William Monroe, according to the 1907–1908 *Ogden City Polk Directory*.

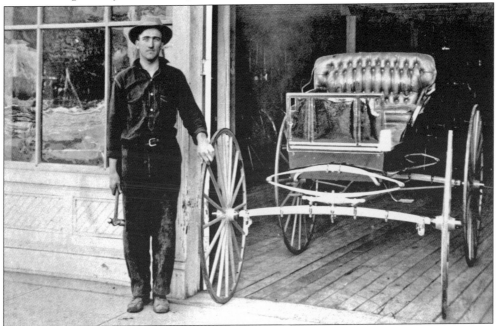

This photograph was taken in 1911 of Asael Ipsen, who was a blacksmith in Ogden. He worked for Savage and Bune, Blacksmiths and Horseshoers. Oscar Savage and James Bune owned the carriage shop located at 2202 Washington Boulevard. They offered carriage and wagon work, along with rubber tires and custom-made wagons.

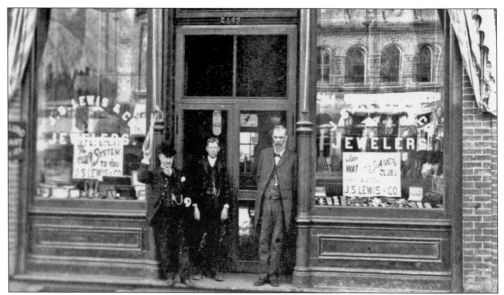

John S. Lewis Sr. arrived in Ogden in 1870. A jeweler by trade, he set up shop at 2461 Washington Boulevard for repairing watches and making custom jewelry in 1879. The Lewis jewelry store was the first in Ogden. His business grew so much that he bought a larger building just next door, at 2463 Washington. John S. Lewis Jewelers had a reputation as one of the finest jewelry stores in the West for 63 years. The company operated until July 1937, when it was sold to the Anderson Jewelry Company. Shown from left to right are John S. Lewis Sr., Hyrum Lewis, and J. S. Lewis Jr., who replaced his father as head of the company after his death in 1882. The bottom photograph is a glimpse inside the Lewis store, with cases of watches and fine jewelry.

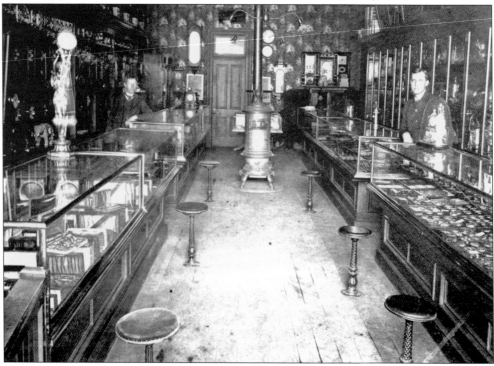

The Ogden Baking Company, billed in 1923 as "Utah's finest bakery," operated a plant at 2557 Grant Avenue. The Ogden Baking Company was best known for their butter-nut bread. Their bread was said to contain many of the essential food requirements for the body of not only children, but adults as well. The company claimed its bread was "high in food value" and "nourishing and health promoting."

The Ogden Knitting Company was located in the Thorstensen Building at 2369 Washington Boulevard in 1920. The company was owned and operated by David Eccles Jr. and David O. McKay, with M. Oslwang as manager. The company manufactured underwear, hosiery, and other knit goods. In 1906, they began to offer overalls as well. The Proudfit Company in the next building has sold sporting goods since its opening in 1902.

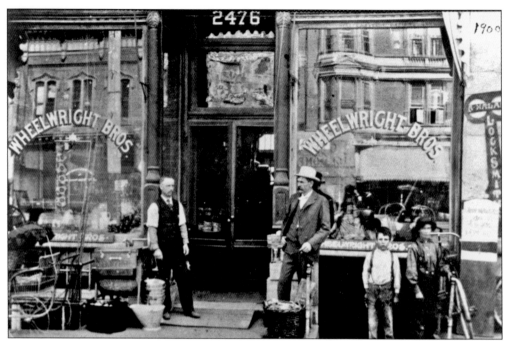

By 1896, the Wheelwright Brothers had opened shop at 2476 Washington Boulevard. The brothers were George, David, Solomon, and Thomas Wheelwright. The store filed saws, fitted keys, repaired stoves, and rented furniture. In 1898, they branched out to sell the latest designs of crockery, lamps, and glassware. The Wheelwright Brothers eventually expanded to include a construction outfit that worked on ditches and laying pipes, and operated a respected lumber company that is still in business.

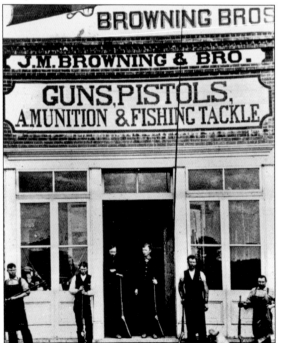

The Browning Brothers store was founded by John M. Browning as a way of selling his gun inventions to the public. Pictured from left to right are Sam, George, John M., Matthew S., and Ed Browning and their British-born gunsmith Frank Rushton outside their first Ogden shop, built in 1880. The company advertised firearms of every description and fishing tackle and that they were the only shop equipped for gun repair in the nation.

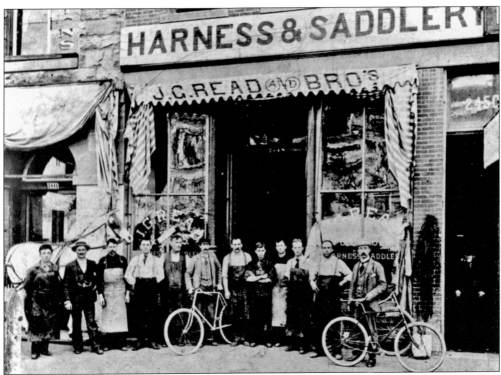

In 1876, Josiah G. Read and his brothers William and Oscar founded the J. G. Read Company on Washington Boulevard between Twenty-fourth and Twenty-fifth Streets. The company made saddles, harnesses, and other leather products. The J. G. Read Company advertised its leather and saddlery hardware, whips, blankets, double and single buggy harnesses, and stock saddles as a specialty in the local paper. Around 1905, the company moved to Kiesel Avenue, where it added car tires to the inventory. In 1912, a statue of a racehorse was put on top of the building, where it stood until the building was torn down in the 1970s to make way for the Ogden City Mall.

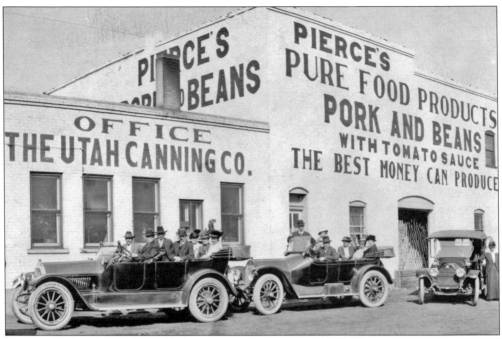

Thomas D. Dee founded the Utah Canning Company in 1897. The company was managed by Isaac N. Pierce and was best known for the Pierce brand, which guaranteed satisfaction under the label of Pierce's pure food products. The Utah Canning Company was best known for its tomatoes and pork and beans. In its first year of operation, the company canned and sold more than 200,000 cans of tomatoes alone. Pictured above is the canning factory located at Twenty-ninth Street and Pacific Avenue. The picture below shows a unique way of advertising the wares. The company placed donkeys with signs outside George Russell Hardware that said, "You don't know beans till you've tasted Pierce's" and "The Daddy of them all—The Utah Canning Company."

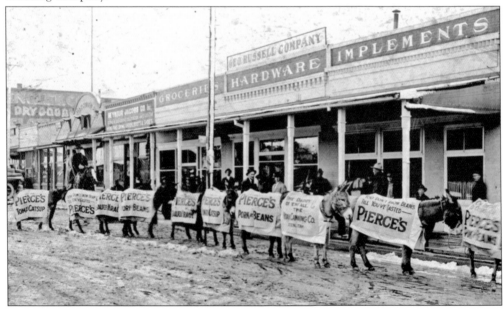

The W. H. Wright department store was founded in 1875 by W. H. Wright and his six sons. They built a two-story building on the west side of Washington Boulevard between Twenty-second and Twenty-third Streets. They sold everything from clothing to notions and even groceries in the early part of the 20th century. By the 1930s, Wright and Sons began to look like an East Coast department store, offering a men's department. Pictured below are the workers in that department standing in front of the hat case and a Kahn Tailoring Company sign. The store finally closed its doors in 1941.

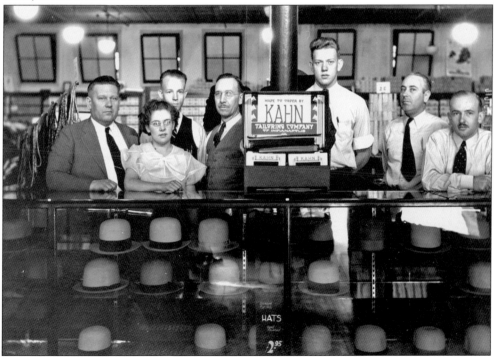

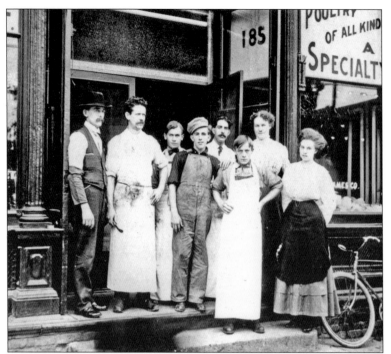

The Chicago Market was owned by the Russell-James Company in the early 1900s and was located at 185 West Twenty-fourth Street. According to one of its advertisements, the company "guaranteed the BEST steak in the city." The company also owned the California Market on Twenty-fifth Street. Pictured here are William A. James (far left) with some of his employees.

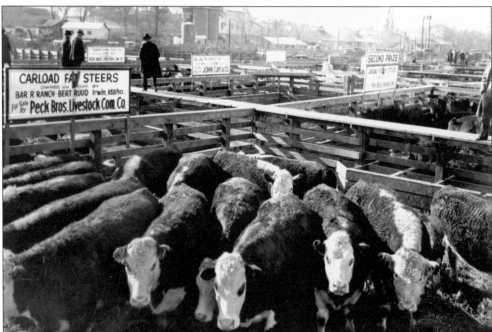

The Ogden Livestock Show was organized in 1918 as an auctioning center for the region's ranchers and brokers. The shows attracted ranchers from the Intermountain West and as far as Chicago. The Exchange Building was built on the grounds of the stockyards as a place to transact the auction business. In 1926, the Ogden Union Stockyards were listed as the largest west of Denver, Colorado, and had seen more than one million head of cattle, sheep, and hogs by that year.

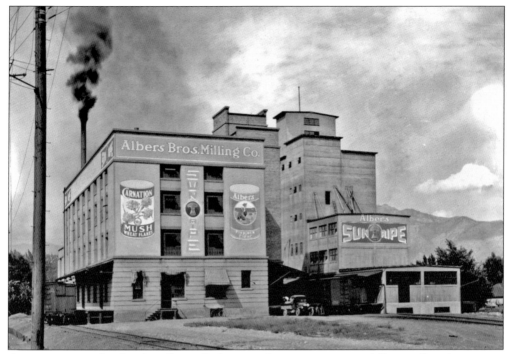

A major source of railroad traffic in Ogden was the grain storage and flour milling businesses. The Albers Brothers Milling Company operated on Twenty-seventh Street. By the 1920s, Ogden became the grain and flour milling center of the West, with 15,000 cars of grain moving through the local yard on a yearly basis. In 1927, the Albers Brother Milling Company was purchased by the Royal Milling Company of Minnesota. The Royal Milling Company had a storage capacity of 400,000 bushels and sold Rex Flour and Miss Utah Flour throughout the West. In 1928, the company merged with Sperry Flour and others to create the General Mills Company.

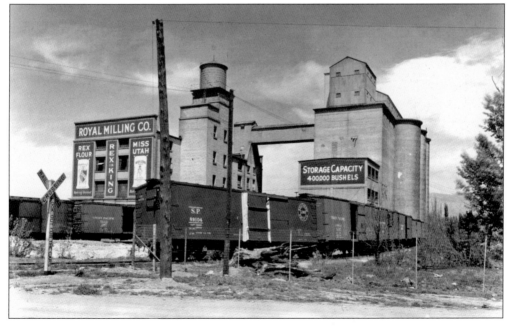

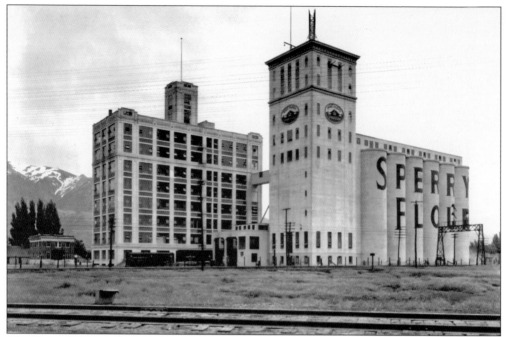

The Sperry Flour mill was located on Twenty-ninth Street and Pacific Avenue. It was one of the many Sperry mills throughout the western United States. The mills had a daily capacity of 13,800 barrels of flour and 1,850 tons of feed grain. In 1928, Sperry became one of the milling, cereal, and elevator companies that formed General Mills. The plant closed in Ogden in 1967.

Amalgamated Sugar, founded in 1915 by a group headed by David Eccles and C. W. Nibley, brought together a number of local beet sugar companies, especially those at Lewiston, Logan, and Ogden. Sugar beets were an important cash crop in Utah from the late 19th to the mid-20th centuries, and its Ogden headquarters and refinery made Amalgamated a significant local economic presence. Its corporate offices are now in Boise, Idaho.

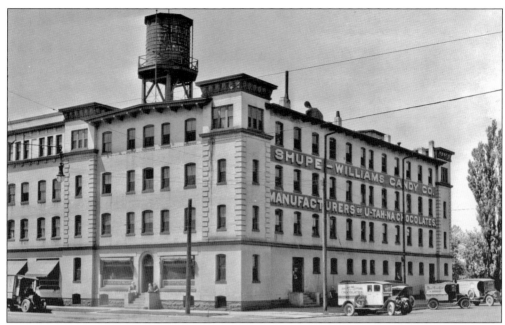

The Shupe-Williams Candy Company was started in 1896 by William Williams and David Shupe. In 1907, the company built a factory on Twenty-sixth Street and Wall Avenue. The company thrived through the 1930s, selling 400 varieties of candy, including hard and soft candies and the Utahna Chocolates. The company finally closed in 1958 after declining sales as a result of World War II. The building burned to the ground in 2006.

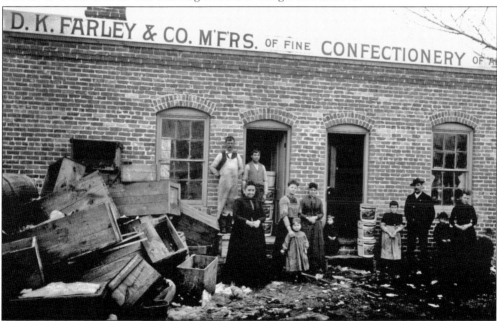

On November 11, 1890, David K. Farley took out a building permit to build a one-story brick candy factory on the west side of Jefferson Avenue. The D. K. Farley and Company competed with the Reeder family for the "taffy-on-a-stick" trade. Farley was out of business by 1900 and went on to own a saloon before his untimely death in 1905 at the age of 38.

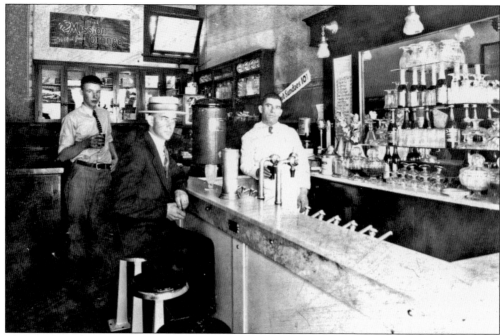

The Little Sweet Shop was located near the corner of Twenty-fifth Street and Washington Boulevard. From the 1920s to the 1940s, it was operated by John Bockeas, a member of the Ogden Chamber of Commerce and a sports enthusiast who supported the athletes of Ogden High and Weber Academy. It was the smallest sweet shop in Ogden but the most popular as a dessert stop for patrons in downtown Ogden. The business sold hard candies, candy canes, bonbons, and boxes of chocolates. They offered soda fountain drinks in addition to the candies. Shown here are two views of the interior of the shop from the 1920s and again in the 1930s after a remodel.

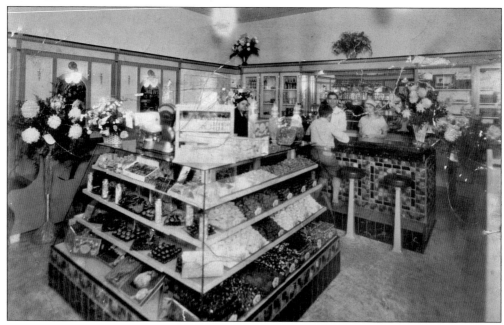

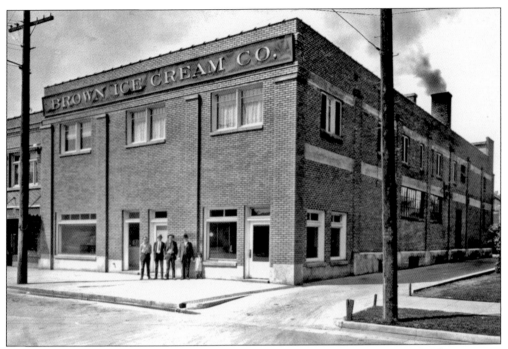

The Brown Ice Cream Company opened its doors at 2577 Grant Avenue in 1907. The company was famous for its chocolate fudge sherbet, angel ice cream, and brick ice cream. They were a popular treat for the people of Ogden and were used in such events as the anniversary of the W. H. Wright and Sons store in 1907.

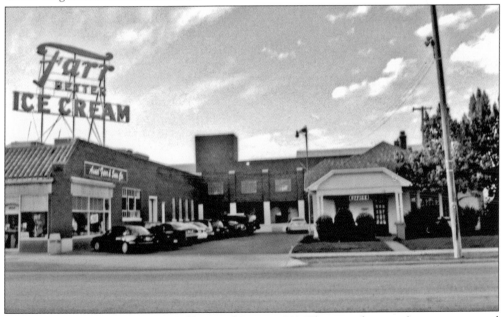

Farr's Better Ice Cream was founded by Asael Farr in 1929. The manufacture of ice cream seemed a natural progression from his commercial ice plant. Farr's Better Ice Cream became Utah's first commercial ice cream plant at 286 Twenty-first Street. The company has developed more than 600 flavors and offers 60 to 70 at any time in its store. (Courtesy of Jessica Johnson.)

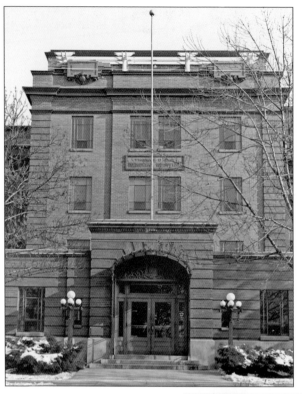

Annie Taylor Dee and her children started the Thomas D. Dee Memorial Hospital in 1910 to bring better health care to the people of Weber County after the death of her son Thomas Reese and her husband, Thomas D. Dee. In the first year, the hospital saw 895 patients. The success of the hospital led to doctor internships and the Dee School of Nursing, which operated from 1913 to 1955. On August 24, 1917, the city dedicated the new Nurses' Home. Among those in attendance were W. W. Rawson (superintendent of the hospital), seated; Mayor Alpheus Fell, standing; Annie T. Dee, in hat; Stella Sainsbury (RN superintendent of nurses), in uniform; and Joseph F. Smith (LDS Church president), on left holding hat.

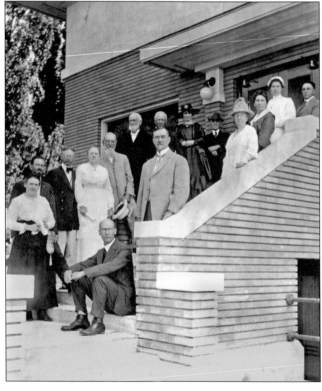

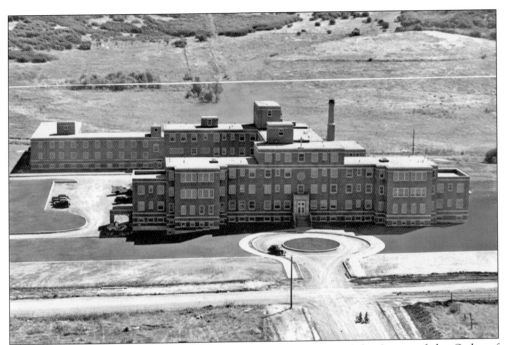

St. Benedict's Hospital opened in 1946 under the sponsorship of the Sisters of the Order of St. Benedict. The hospital was located at 3000 Polk Avenue until a new hospital was built in south Ogden in 1977. Sister Mary Margaret was the first administrator of the hospital. The Sisters embraced the community with their gentle caring and their approach to healing. Currently, the building functions as condominium residences.

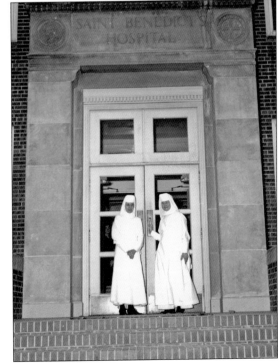

The Sisters of St. Benedict came to Ogden from Minnesota in 1944 at the request of city officials to build and operate St. Benedict's Hospital. In August 1994, the Sisters requested to be organized as a separate monastery. Pictured are Sister Mary Margaret (left) and Sister Estelle in front of St. Benedict's in 1944. (Courtesy of Mount Benedict Monastery.)

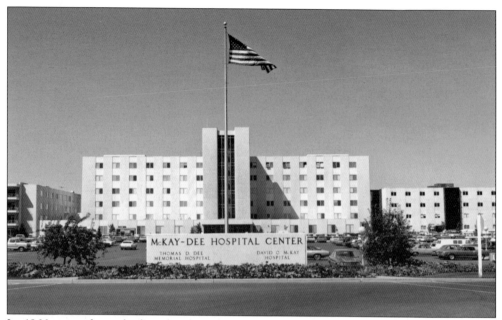

In 1966, ground was broken for the new McKay-Dee Hospital, named after LDS president David O. McKay, on the west side of 4000 Harrison Boulevard. In 1969, the initial building was completed, with the Dee wing to follow. The Dee family closed the Dee hospital that same year and joined with the LDS Church to form Intermountain Health Care. The McKay-Dee Hospital operated the facility until 2002, when a new hospital was built.

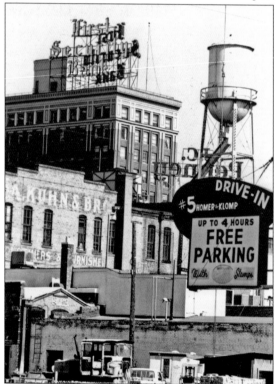

Pictured here are the First Security Bank Building at 2404 Washington Boulevard and the surrounding businesses. The old J. C. Penney store sign is visible, along with "A. Kuhn and Brothers," which can be seen on the side of the building. The Kuhn brothers, Adam and Abraham, in 1880 moved their clothing and dry-goods store from Corinne to Ogden.

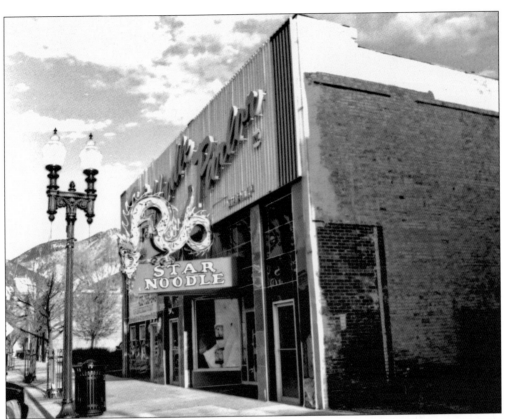

With the railroad bringing immigrants from around the world, a section of Ogden from Kiesel to Wall Avenues and Twenty-fourth and Twenty-fifth Streets became known as Japan Town. Two of the major businesses in that area were the Star Noodle Parlor and the Utah Noodle House. The Star Noodle Parlor operated from 1927 until it closed in 2007. K. Yamamato opened the restaurant, located at 265 Twenty-fifth Street. It offered Asian and domestic foods. T. Ryujin took over the management of the Star Noodle Parlor in 1948, operating it until it closed. Sam N. Mido opened the Utah Noodle House at 2430 Grant Avenue in 1930. The Utah Noodle House is known for its chop suey and noodles and jumbo fried shrimp. In the 1950s, Leo and Mamiyo Iseki took over the restaurant, and in 1970, they moved it to its present location at 3019 Washington Boulevard. (Both, courtesy of Jessica Johnson.)

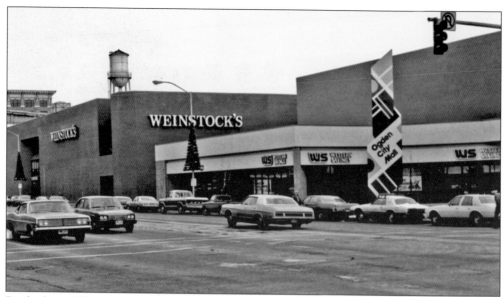

By the late 1970s, businesses in downtown Ogden started to slow down. In order to remedy the problem, the City of Ogden contracted to build the Ogden City Mall on Washington Boulevard between Twenty-second and Twenty-fourth Streets. To make the necessary space to build the mall with anchor stores like Nordstrom, ZCMI, and J. C. Penney, old businesses were torn down. The mall was demolished in 2003.

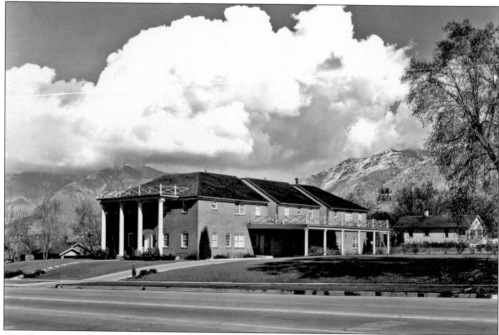

Charles Lindquist moved to Ogden in 1885 and established the Lindquist mortuary. After his death in 1934, his son John A. Lindquist took over the family business. In 1941, construction began on the Lindquist main mortuary facility, located at 3408 Washington Boulevard. In 1942, the building was dedicated as the Lindquist Colonial Chapel by David O. McKay. It continues to serve the people of Weber County.

86

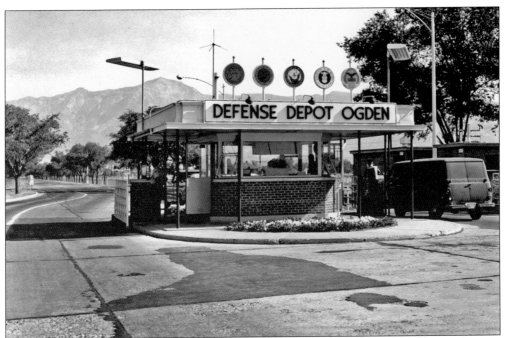

During World War II, the House Military Affairs Committee approved emergency funds to create new military posts. The Utah General Depot, later known as Defense Depot Ogden, was one of those posts, located in west Ogden from Twelfth Street north to Second Street. It was a storage depot of general equipment to furnish the needed supplies to 500,000 men. This was the main entrance to the Defense Depot Ogden.

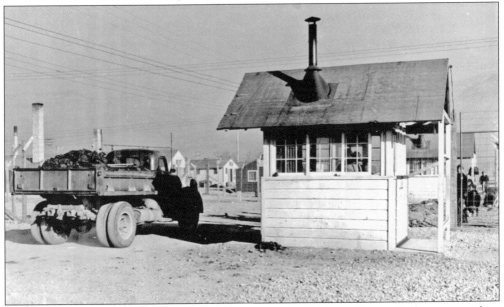

With the establishment of the POW camp at the Defense Depot Ogden, more than 7,000 Italians and Germans were sent to Ogden. Pictured here is one of the guarded entrances to the POW camp section of DDO. The guardhouse is in front of the fencing to monitor the traffic in and out of the camp. In the right corner, a few of the prisoners can be seen working.

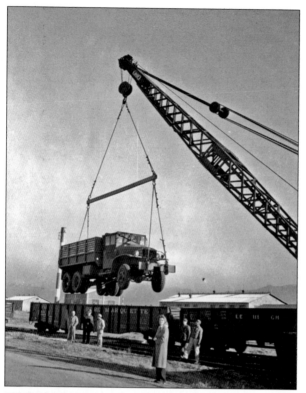

Along with the Defense Depot Ogden, two other military installations opened in the Ogden area during World War II. The Ogden Arsenal was created for the manufacture and storage of bombs, shells, and other ammunition. It later became a motor base for the ready storage of combat vehicles. Pictured at left is a heavy-duty battler that had been shipped into the Ogden Arsenal. There it was checked and serviced, and then shipped on to overseas destinations. The other installation was the Ogden Air Depot, located at Hill Field. From left to right, Donald Ransomer, Pvt. Jack Hyde, and Jean Gillies practice the disassembly of an army bomber radial engine.

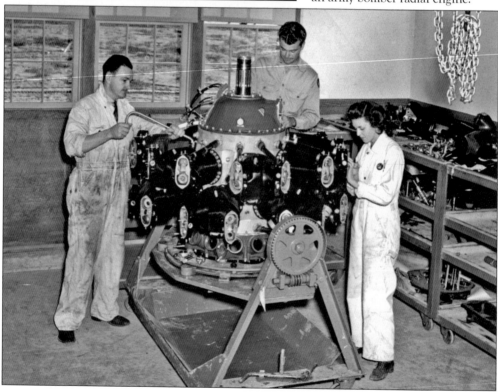

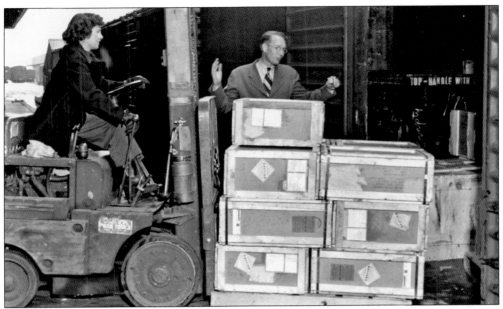

With men being sent overseas to fight in World War II, more women were joining the workforce. The Defense Depot Ogden offered many jobs to women with no warehouse experience. Above is Elma Compton operating the forklift as her supervisor, H. H. Kipp, directs the loading operation of crates of aircraft material into waiting freight cars. In December 1941, the depot received 3,420 tons of materials and shipped 1,426 tons. The depot worked around the clock with three shifts daily and overtime to keep up with the highly accelerated workload. In the photograph below, several men and women are working on loading crates of Armour corned beef to be shipped to the troops overseas.

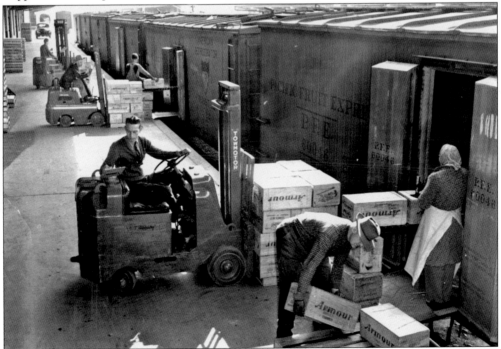

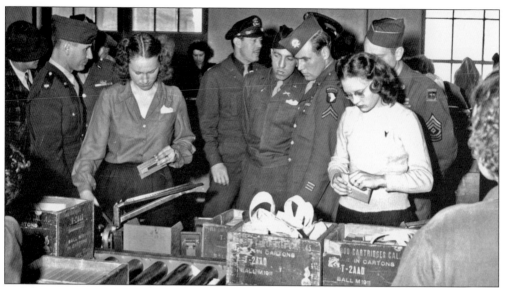

In February 1945, the Signal Supply Section at the Defense Depot Ogden was given a mission entitled "Utah Project." With the progress in the Pacific theater, the supplies needed to be packed without the knowledge of their ultimate destination. The ships would be loaded with supplies for all branches of service. In March of that year, veterans who fought at the Battle of the Bulge visited the Ogden Arsenal to see how their ammunition was packaged for transport. In the photograph below, members of the Ogden City Council tour the depot. The seated woman is preparing a service uniform. The depot was responsible for the clothing of enlisted women, WAC officers, army nurses, hospital dieticians, and physical therapists.

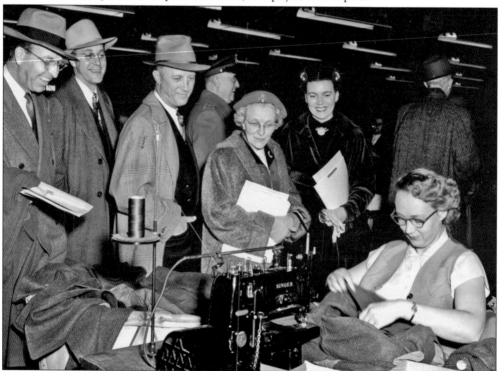

Seven

A Splendid Outing with Sports and Recreation

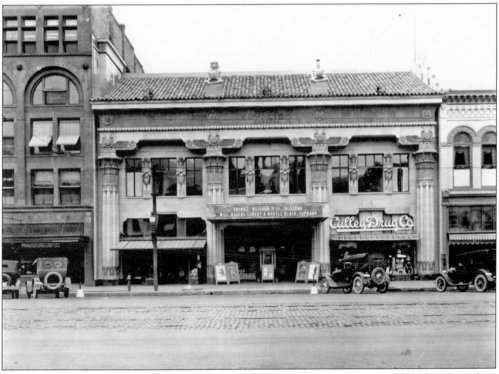

In 1923, Harman and Louis Peery set about to build a movie palace that would be "the Showplace of the West." Leslie Hodgson designed the Egyptian Theater after the King Tut mania happening at the time and after Grauman's Theater in Hollywood. The 1,200-seat theater opened in 1924, complete with twinkling lights in the ceiling. It was billed as Ogden's only fireproof theater and a safe place for children.

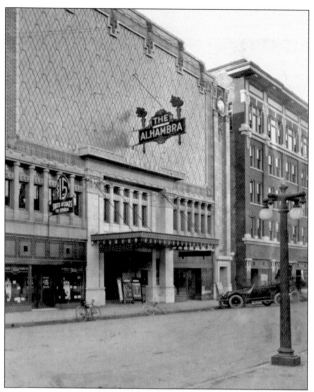

In 1915, the Alhambra Theater opened in Ogden at 2529 Kiesel Avenue. It was the largest theater in Ogden at the time and showed movies from 1920 to 1925. It also held live wrestling matches. Pictured at left, the theater is offering Mary Pickford in *Poor Little Peppina* in 1916 for the admission price of 5¢ and 10¢. The Alhambra was sold and became the Paramount Theater in 1926. Movies from Paramount Pictures became the feature draw at the theater as one of the owners of Paramount, W. W. Hodkinson, hailed from Ogden. One of the first movies shown was *Nell Gwyn*. The theater was torn down in 1971. (Below, courtesy of John Shupe.)

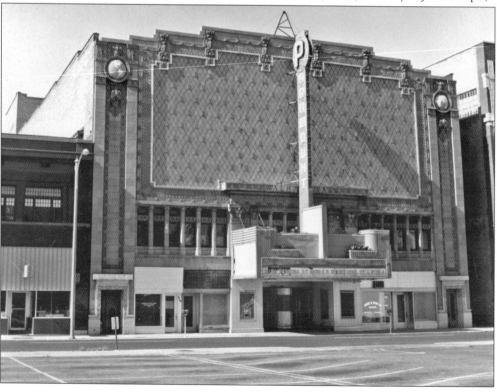

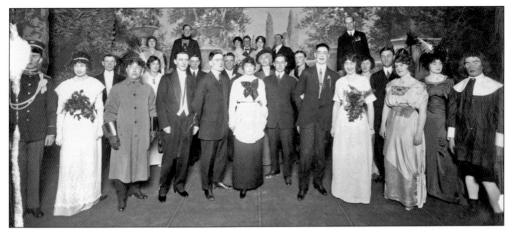

The Grand Opera House was renamed the Orpheum Theater after it was remodelled in 1909. The theater became part of the Orpheum circuit and was home to a large number of vaudeville acts during the 1920s. Animals of all sorts, as well as musicians, magicians, singers, and speakers, appeared on the stage. This picture is the cast of *The Senior*, a play that was performed in the theater in February 1914.

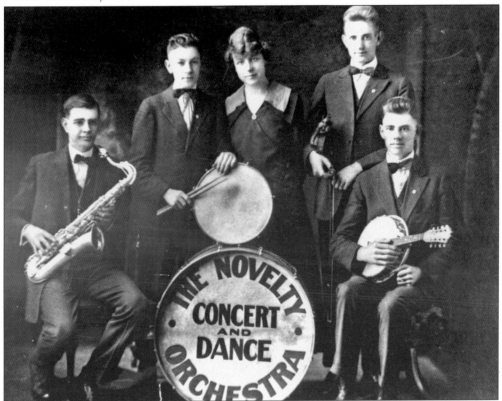

The Hermitage Resort in Ogden Canyon was a popular getaway destination for the folks of Ogden. Various groups and clubs, such as the Elks and the Ida No Club, held dances at the Hermitage on a weekly basis. Pictured here are the Novelty Concert and Dance Orchestra in 1917–1918. The orchestra included Alden Pettigrew on banjo, Harold Pettigrew on violin, and Mae Willis on piano. The others are unidentified.

Harman Peery owned and operated the White City Ballroom when it opened in 1922 on Twenty-fifth Street. The White City Ballroom held Charleston dance contests in 1925 for a cash prize of $500. It was open for dancing every Tuesday, Thursday, and Saturday. The ballroom finally shut its doors in 1979.

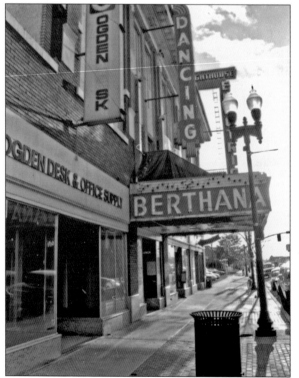

The Berthana was built by Annie Dee and Bertha Eccles in 1914 as a social and cultural center for Ogden. It was once a thriving dance hall, providing a space for high school and college dances. It also played host to private parties for the Dee and Eccles families, along with the clubs and social organizations around Ogden. In the 1950s, it was converted to a roller rink. (Courtesy of Jessica Johnson.)

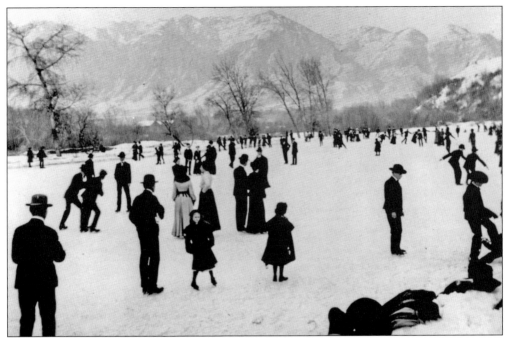

Glenwood Park in the 1890s was a popular recreation spot for the population of Ogden. The city worked to make the park a resort destination, with swings, a Ferris wheel, an amphitheater, platforms, sports grounds, and lakes. Located at Sixteenth Street and Monroe Avenue, people are seen here enjoying skating on the pond.

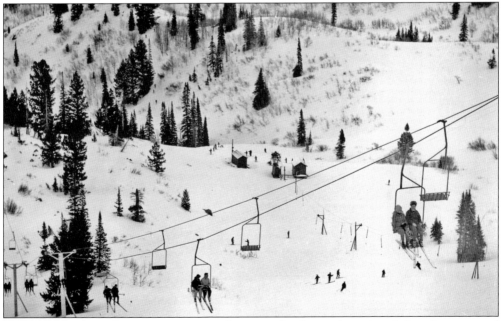

In the 1920s, skiing became a recreational activity for those who enjoyed the adventure and splendor of Utah's winters. In Ogden, Becker Hill became a professional ski-jumping hill, just east of Ogden Canyon. By the 1930s, the U.S. Forest Service and ski jumper Alf Engen decided that Wheeler Basin, later named Snowbasin, would be a "huge public playground."

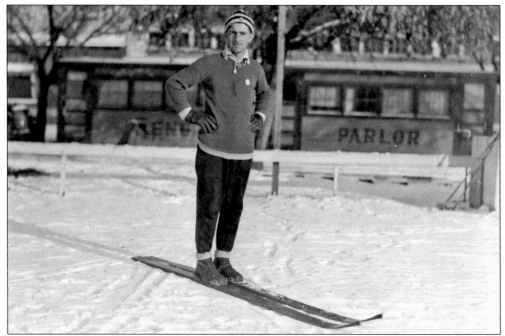

In the 1940s, Snowbasin attracted visitors worldwide to the canyons of Ogden for skiing and ski jumping. Pictured here is a man who looks ready to try his hand at the ski jump on Becker Hill, which played host to professional ski-jumping contests that thrilled thousands of spectators. Pictured below are a man and woman enjoying the beautiful skiing conditions at one of Ogden's resorts. The first ski school at Snowbasin was opened in 1941 by Sverre and Corey Engen. Recreation skiing grew in Ogden thanks to the enthusiasm of the 10th Mountain Division after World War II. These men used their expert skiing skills to avoid enemies during the war.

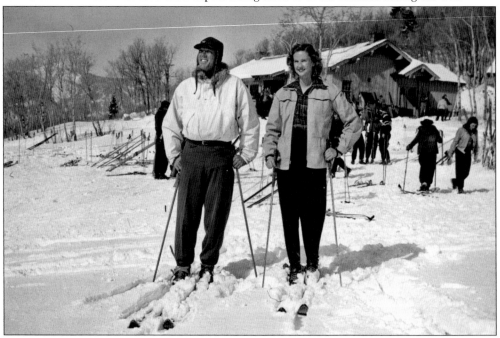

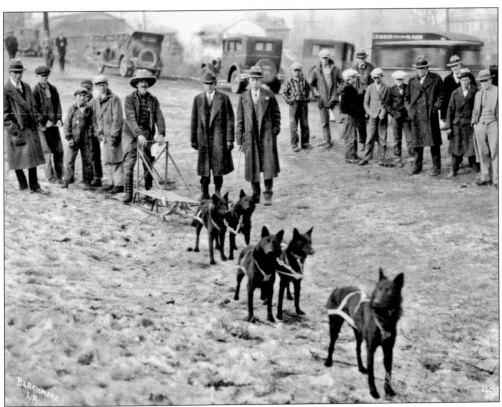

During the 1930s, dogsled racing became an important winter pastime in Ogden. The racers practiced in the streets of Ogden even before there was any snow on the ground, as depicted in the picture above. This gentleman and five dogs practiced on the rough roads on the outskirts of Ogden. Pictured at right is Utah governor George H. Dern presenting the cup to the winner (Earl Kimball, wearing the number 6) of the first annual Wasatch Dog Derby at Becker Hill in Ogden Canyon. The race took place over two days in February 1930 during the Winter Sports Carnival.

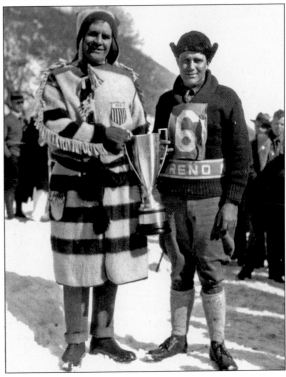

In 1962, Jerry Green, president of the Retail Merchants Committee, spearheaded the creation of the Christmas Village. The first village consisted of Santa's Castle, a Candy Shop, a Toy Shop, and a Post Office. The first year saw more than 10,000 visitors. This picture shows a group of people waiting in line to enter the Christmas Village. Since its beginning, the Christmas Village has grown and attracted visitors from great distances as well as locals.

Parks in Ogden City were used for holiday celebrations as well as everyday activities when the weather permitted. Most of the parks have become prominent playgrounds for children. The City Park, located in downtown Ogden, provided facilities for both young and old to enjoy. Pictured here are two groups of gentlemen taking advantage of the checkers games in the 1940s.

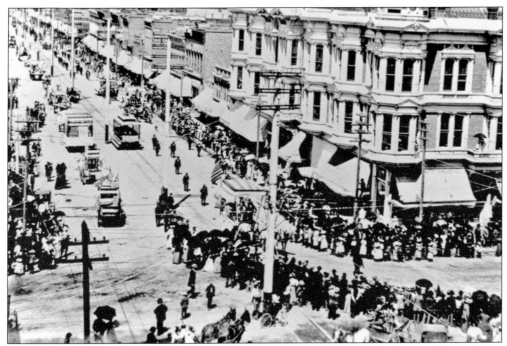

The citizens of Ogden liked to celebrate national holidays with grand events. This was the Fourth of July parade in 1896. The people of Ogden were treated to parades, speeches, and festivities along Washington Boulevard. The parade route turned down Twenty-fifth Street and headed toward the Union Station. Ogden also celebrated the entrance of Utah into the United States just six months earlier.

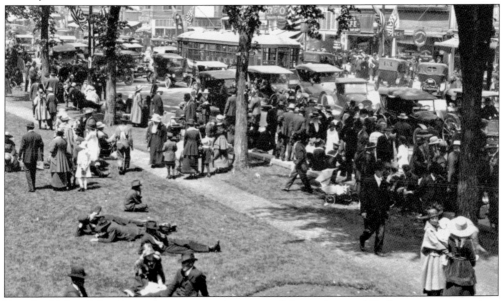

Fourth of July celebrations were commonplace around the nation, and Ogden was no exception. On that day every year, crowds gathered in downtown Ogden to celebrate the independence of the United States. People gathered in Municipal Square on Twenty-fifth Street and Washington Boulevard, and had picnics and enjoyed the festivities put on by local officials.

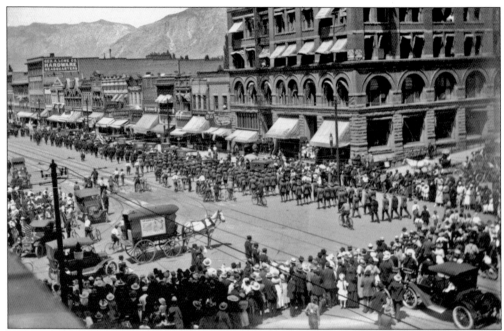

On March 15, 1919, soldiers from the 91st Infantry Division and 145th Field Artillery returned home to Ogden from service in France and Belgium during World War I. They received a hero's welcome from the citizens of Ogden. Although local officials had warned against gathering crowds because of the influenza outbreak, the people of Ogden would not let the gentlemen return home without some sort of fanfare. The troops were ordered to march on parade from the train depot up Twenty-fifth Street and along Washington Boulevard. They were greeted with signs, flags, banners, and bands trumpeting the victory in Europe. Family and friends clamored to greet their returning soldiers and were left alone by the officials.

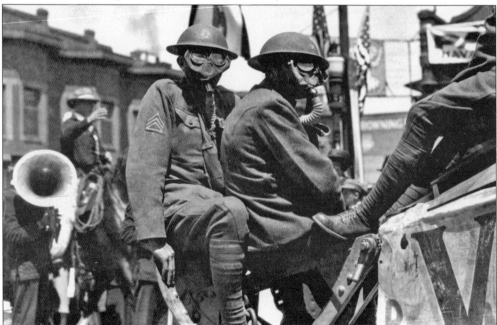

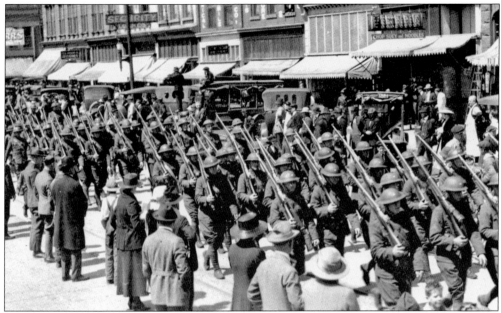

When World War I ended on November 11, 1918, the citizens of Ogden—like everyone else in the nation—were glad to see an end to the conflict, which they had supported by collecting money for the Red Cross and buying Liberty bonds. They marked the event with dancing and fireworks. The official celebration, however, came two years later in 1920, when Ogden observed Armistice Day with a parade that closed the downtown business district, and hundreds of citizens lined the streets. The photograph above shows the troops marching down Washington Boulevard, surrounded by well-wishers. Shown below are returning Ogden soldiers riding down Washington Boulevard at Twenty-fifth Street on a tank. Note the corner of the Broom Hotel on the left and the evidence of American flags and patriotic bunting.

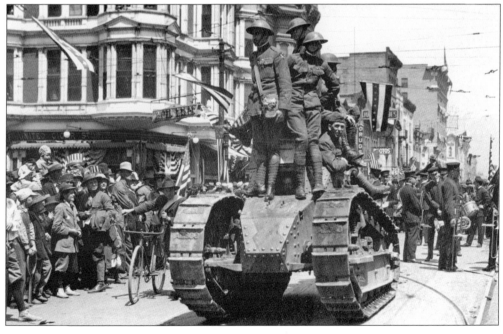

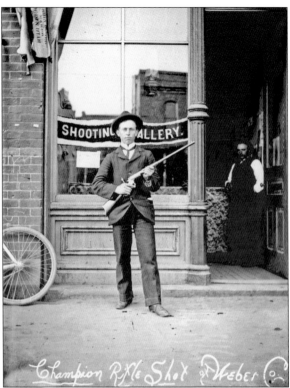

Charles MacCarthy, shown here, was the champion rifle shot of Weber County from 1901 to 1904. In the June 16, 1899, Ogden paper, Newton Farr openly challenged MacCarthy to a rifle shot contest. He said, "Dear Sir: I hereby challenge you for the championship 10 shots and supper." It was commonplace for the loser to buy the winner's supper.

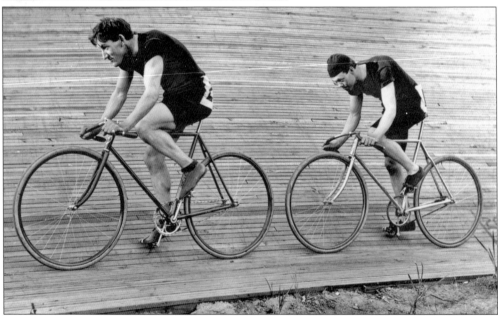

At the dawn of the 20th century, bicycle racing was a major pastime in Ogden. The riders would race on a wooden racing track called the "saucer." Ogden's track was at the site of present-day Lorin Farr Park, with admission at 25¢ and 50¢. The attendance at the races sometimes reached 2,000. Charles MacCarthy (front), known to set many records, and an unidentified fellow racer are shown in the photograph.

During the summer of 1948, Ogden was witness to the All-American Soap Box Derby. Pictured here is the starting point, with two cars ready to go. One of the boys had a sponsor in Bob's Market, a local business. Paul Sandrop was named the official winner of the soap box derby.

On the night of January 10, 1947, some 1,800 citizens of Ogden started a new tradition with the "Spirit of the Pines" at Affleck Park. The burning trees depicted how the bad things of life should be discarded and the good ones taken up. The boys had Miss Liberty light their torches before they headed to the pile of Christmas trees. They also burned effigies of drunkenness, crime, and ignorance.

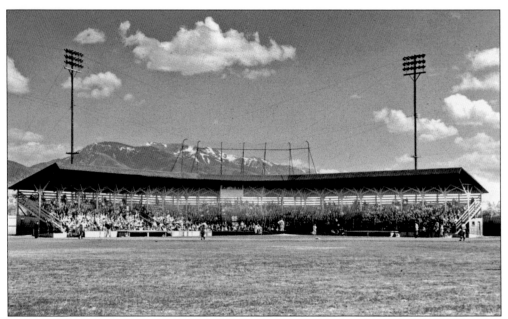

Affleck Park was Ogden's baseball home from 1940 to 1980. Operating in both the Pioneer and Pacific Coast Leagues, Ogden was a farm team of the Reds, Dodgers, and As. Many future major leaguers saw action there, including Johnny Temple, Steve Garvey, and Rickey Henderson. Tommy Lasorda managed the Ogden Dodgers from 1966 to 1968. After the Ogden Athletics left in 1980, the stadium was razed, and the property was converted to commercial use.

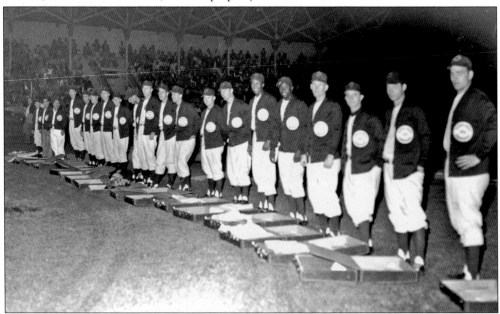

Hall of Fame member Frank Robinson, shown here sixth from the right, broke into professional baseball at the age of 18 with the 1953 Ogden Reds. Rookie of the Year with Cincinnati three years later, Robinson had a 21-year career, playing for five different teams and seeing many honors, including MVP in the National and American Leagues in 1961 and 1966 respectively. In 1975, he became the first black major league manager with Cleveland.

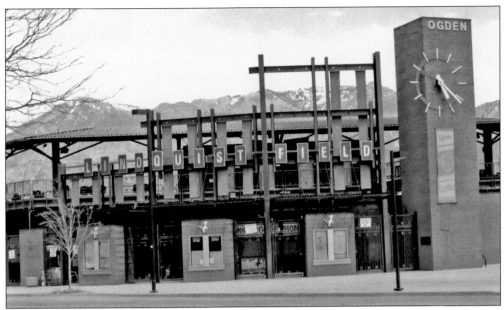

Opened in 1997 with a seating capacity of 5,000, Lindquist Field is home to the Pioneer League Ogden Raptors. The team came to Ogden in 1995 as an independent but was later affiliated with the Milwaukee Brewers and the Los Angeles Dodgers. Located in downtown Ogden with the mountains as a backdrop, in 2007, the park was named the "No. 1 view in professional baseball." A 2008 expansion will increase seating to approximately 8,000. (Courtesy of Sarah Langsdon.)

Like Frank Robinson, Prince Fielder broke into professional baseball as an 18-year-old rookie with Ogden in 2002. After 41 games with the Raptors, where he hit .390 with 10 homers, he moved on to Beloit, Huntsville, and Nashville before joining the Milwaukee Brewers in 2005. In 2007, he was elected to the American League All-Star team and became the youngest player in Major League history to hit 50 home runs, setting the franchise record as well. (Courtesy of Scott Paulus, Milwaukee Brewers.)

The Ogden Pioneer Days were started by Harman Peery in 1934. As the "Cowboy Mayor" of Ogden, Peery tried to attract national attention to Ogden through his antics. He held a beard-growing contest in 1935 with the decision made during the Pioneer Days festivities. Also during that year, the first rodeo was held in the Ogden Stadium. Pictured above are some of the men responsible for the running of the celebration. As part of Pioneer Days, there is a parade held in Ogden down Washington Boulevard. Crowds gather early in the morning to get a good seat as they watch more than 100 floats go by, including the Rodeo Queen Court on horseback.

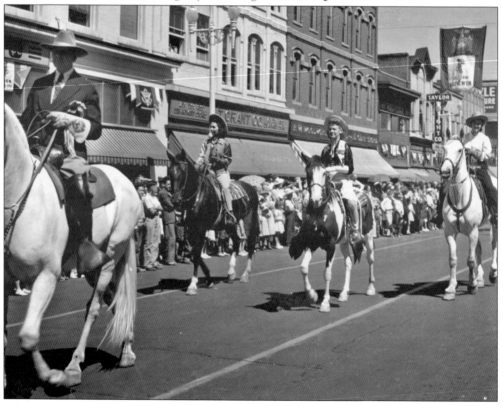

Eight

OGDEN CANYON
THE BEAUTIFUL ROMANTIC GORGE

At the mouth of the Ogden Canyon is Bridal Veil Falls. This is an artificial waterfall coming from the overflow of the city pipeline that transferred water from the canyon down to Ogden. The mountainside is still rugged, and the waterfall shows off its natural beauty. This photograph was taken in 1893 by Ogden photographer and jeweler Paul Stecher.

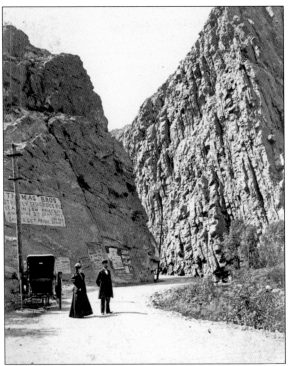

Ogden Canyon had a narrow gateway entrance, which had to be blasted to build a wider road. Once this road was completed in 1860, the citizens of Ogden would flock to the canyon to enjoy the nature and resorts the area had to offer. To take full advantage of this, many businesses, including Thomas Brothers, would place signs on the rock walls near the entrance of the canyon advertising their wares.

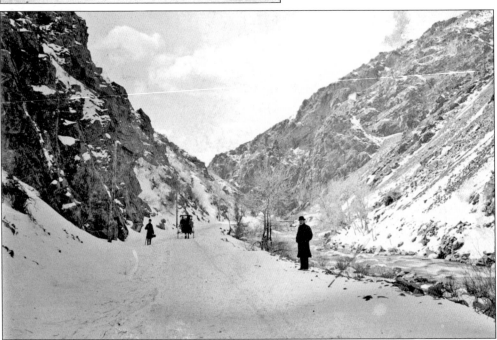

In 1857, construction on a road through Ogden Canyon was started to provide easier access to timber. The work was arduous and plagued with floods and snow. When the road was completed, a tollgate was built at the mouth of the canyon to collect tolls to pay the expenses of building the road and to maintain the yearly repairs. This photograph of the early road was taken by Paul Stecher in 1893.

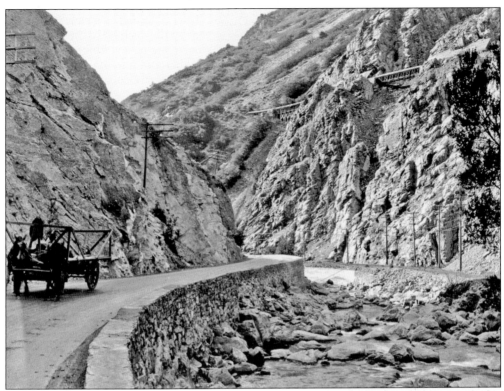

In 1921, the P. J. Moran Construction Company began building the road from the mouth of the canyon to the outskirts of Huntsville. The paving of the 7.5-mile-long road was completed on July 13, 1921. The grand-opening ceremonies were officiated by Utah governor Charles R. Mabey and included a pageant, music, and addresses. Within 20 minutes, the first automobile made the trip over the newly paved road. Pictured above is a wagon and horses venturing up the road in 1922. The photograph at right is of early cars making their way up the canyon.

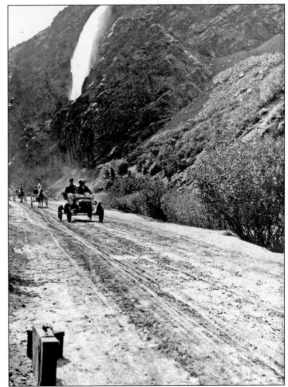

The P. J. Moran Company not only paved the road up Ogden Canyon, but it also built a drinking fountain in the canyon. The fountain was at Cold Water Canyon. It had two places where water was flowing continually and also a large stream where water could be secured for automobiles.

The artesian wells were a long-untapped source of water for the city until 1923, when it was decided that the wells could provide significant flow to the city with its water. Pictured here is the Artesian Wells Park main building and several wells in 1920. Before the city took control, it was a popular tourist spot in Ogden Canyon, with many out-of-towners taking a drive up the canyon to see the wells.

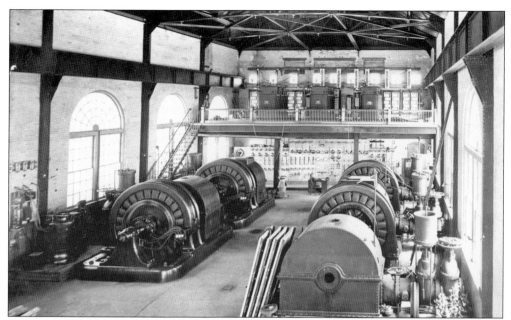

The Pioneer Power Plant was built in 1897 at the mouth of Ogden Canyon. It was built to utilize the water in the Ogden River for the development of power and irrigation. The central features of the plant were a large reservoir and a powerhouse containing waterwheels and electric generators. This picture shows the interior of the power plant.

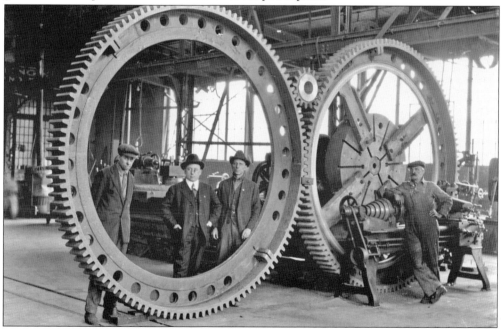

The Utah Power and Light Company was formed in 1912. It was organized to consolidate the many electric companies, taking over the larger and smaller firms. The company began operating in Ogden in 1913. During that time, it took over the Pioneer Electric Power Company, which drew hydroelectric power from the Ogden River. Pictured here is the inside of one of those plants, showing the massive machinery needed to power a city.

The Ogden River not only provided water for the citizens of Ogden, but it was also known for its fishing. People would flock to the river during the summer months to catch fish for their picnics or hunting parties. During late springtime, the river can become dangerous as the winter mountain snow melts and the river flows with violence and turbulence. As Frederick J. Pack stated, "To the traveler on the nearby well-graded road, its lashing waves and noise of grinding boulders are a source of wonder and awe, but to the unfortunate victim who by chance becomes entangled in its waters, it is immediately a source of instant death." Pictured here are the frozen waterfall and the Ogden River during the early spring runoff.

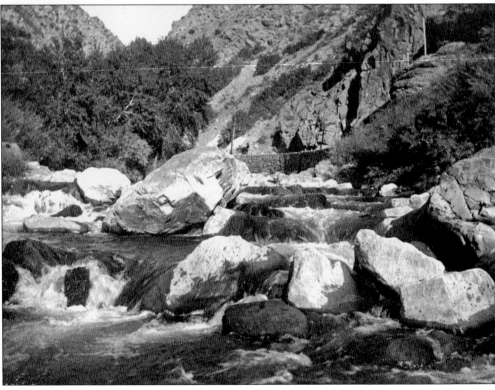

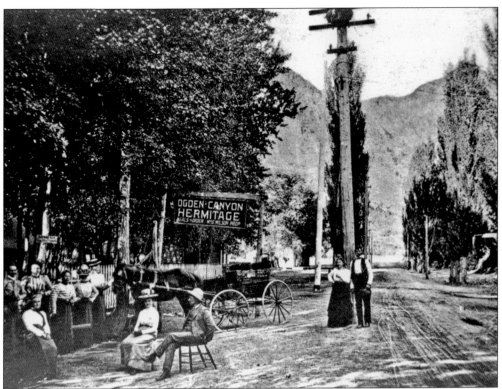

The Hermitage Resort opened its doors in the Ogden Canyon in the summer of 1893, according to the *Ogden Standard Examiner*. The resort advertised meals at all hours. One of the first events held at the Hermitage was for the Grand Army of the Republic. They had dinner, a speaker, and music outside in the grove. The Hermitage was a popular dance and dining destination for the people of Ogden looking for a getaway. The hotel was famous for its chicken and trout dinners. Even in the winters, the Hermitage provided a wonderful place for cross-country skiing and lodging in one of its 41 rooms in the two-story hotel.

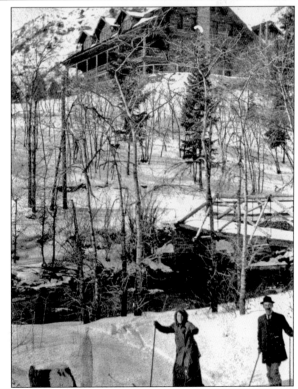

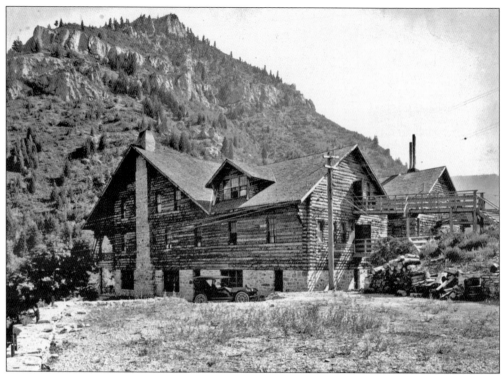

Improved roads up the canyon lured many Sunday drivers to the popular summer resort in Winslow's Grove. The resort provided excellent boating and fishing at the local pond. The Hermitage was once the playground of former U.S. presidents William H. Taft and Theodore Roosevelt. The resort was eventually destroyed by fire in 1939.

Located at the mouth of Ogden Canyon, the Ogden Canyon Sanitarium was built in 1903 by a group of investors. These gentlemen were hoping to use the springs that were rumored to have medicinal values to draw crowds to the resort to soak in the baths. In 1906, the Ogden Rapid Transit extended its line to the sanitarium and brought bathers to the resort. The building is now a restaurant and specialty store.

Ogden Canyon provided land suitable for parks, resorts, and summer residences. During much of the year, Ogden residents retreat to the canyon to escape the higher temperatures. The canyon fast became an important playground for the people of Weber County. The Oaks Resort, owned and operated by C. S. Potter, was just one of the places people flocked to. In the present day, it is still a popular summertime dining location.

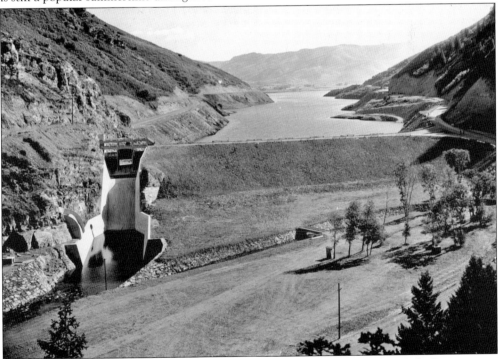

Pineview Dam, located in Ogden Canyon, was built in the 1930s by the Utah Construction Company. It was part of the Ogden River Project that was to provide reliable irrigation and flood control to Ogden and the surrounding areas. It is now a popular summer destination for Northern Utah. The dam provides recreational activities such as boating, water-skiing, and fishing.

Ogden Canyon, with its many streams, is well known for its fishing. In a newspaper article in 1880, a group of men passed through all the good fishing places and caught enough fish to feed the entire party. Fishing parties were common in the canyon during the summer.

People often drove to Ogden Canyon for family picnics during the summer. The canyon offered beauty, shade, and an escape from the summer heat. Pictured here are members of Charles MacCarthy's family enjoying watermelon in one of the many picnic grounds dotted throughout the trees in the canyon. Even the children seem to take pleasure in this summer tradition.

Nine

HAVING A GOOD TIME WITH OGDEN POSTCARDS

This is a "Greetings from Ogden" postcard from the 1940s. In each of the letters in the name "Ogden" is a different view from the area. O is the new City and County Building. G is a view looking down Ogden Canyon. D is Washington Boulevard, with E showing Pineview Lake. N is the Cache National Forest, which includes many of the recreational areas in Ogden like Snowbasin.

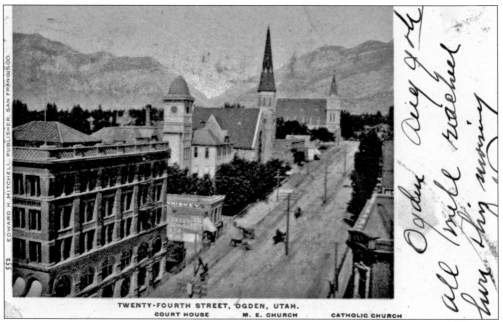

TWENTY-FOURTH STREET, OGDEN, UTAH.
COURT HOUSE M. E. CHURCH CATHOLIC CHURCH

This postcard is a drawing of Twenty-fourth Street looking east from Washington Boulevard toward the Wasatch Mountains. The postcard shows the Weber County Courthouse, the First Methodist Church, and St. Joseph's Catholic Church at the top. It also depicts the First National Bank on the corner of Twenty-fourth and Washington, a dealer in whiskey, and G. E. Cross, a manufacturer of harness and saddlery.

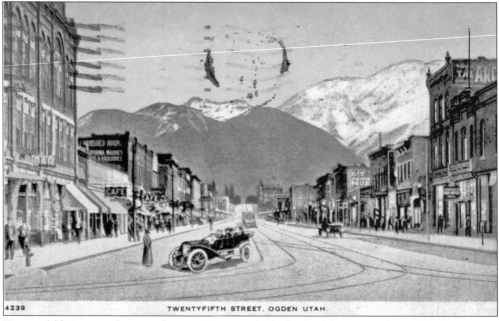

TWENTYFIFTH STREET, OGDEN UTAH.

Twenty-fifth Street is showcased in a 1918 postcard. The back of the postcard gives this description of Ogden: "Ogden, the second largest city in Utah and known as 'The Railroad Gateway to the West' is situated in the richest agricultural region of Utah. Its public buildings and institutions are its pride. Ogden won first prize as the first city in the first class in Utah."

118

15864. Washington Ave. looking North, Ogden, Utah

The postcard shown here is looking north on Washington Boulevard, known as the main business street of this bustling "Junction City." Its business structures will compare with cities of much greater size anywhere. This postcard was issued in 1947. Prominently featured are the Ben Lomond Hotel, Orpheum Theater, Plaza Hotel, and Jones Music Company.

CITY PARK, OGDEN, UTAH, SHOWING SNOW-CAPPED MOUNT OGDEN IN BACKGROUND

The picture on this postcard was taken from Twenty-fifth Street and shows the new bus depot in the lower right-hand corner. The tall building on the right is the City and County Building housing the offices of Ogden City and Weber County. The other tall building is the Ben Lomond Hotel. In the foreground is the Ogden City Park with part of the business section shown.

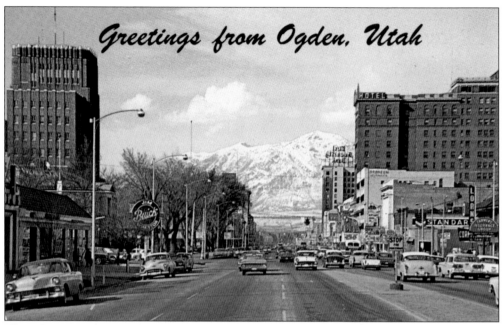

Greetings from Ogden, Utah

This "Greetings from Ogden" postcard is a photograph looking north on Ogden's Washington Boulevard, with snow-capped Mount Ben Lomond in the background. Here in the 1950s, many of the smaller businesses are no longer part of downtown, including Jim's Buick showroom, the Standard Building, and the Orpheum Theater. The busy street is filled with cars and a lone sign reminding drivers to "stop for pedestrians."

OGDEN COUNTRY CLUB WITH CITY TO THE NORTH, OGDEN, UTAH

The Ogden Country Club was a privately owned club established in 1914. It is still the oldest continuously operated country club in Utah. It was built on the south end of Ogden at 4197 Washington Boulevard, with the golf course straddling both sides of Washington. In the club's early years, many of the prominent families of Ogden played golf or enjoyed the amenities of the clubhouse.

Lynada Motel
2744 Washington Blvd. (U. S. 91-89-30 So.) Ogden, Utah.

Recommended by Duncan Hines in "Lodging for a Night."

The Lynada Motel was located in the heart of downtown Ogden at 2744 Washington Boulevard. The motel offered 21 units, each with a combination tiled tub and shower. They had amenities such as kitchenettes, radios, and garages. The motel advertised that it was recommended by Duncan Hines in "Lodging for a Night."

MOUNTAIN VIEW AUTO COURT
PHONE 4416 563 WEST TWENTY-FOURTH OGDEN, UTAH

The Mountain View Auto Court was located on U.S. 38 in Ogden at 563 West Twenty-fourth Street. The motel offered 27 apartments that were all steam heated. Each room had a combination bath and shower. They supplied full electric equipment with everything furnished. They did recommend that guests "bring only your grip." They advertised reasonable rates and invited inspections from prospective guests.

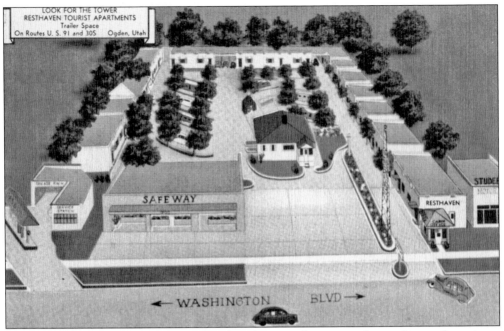

The Resthaven Tourist Apartments offered trailer space for tourists. Located just a five-minute walk from the center of the business district at 1910 Washington Boulevard, the apartments were an alternative to the busyness of downtown. The Resthaven Apartments advertisement was, "Look for the Tower Resthaven—The Home Camp where strangers are welcome and feel at home."

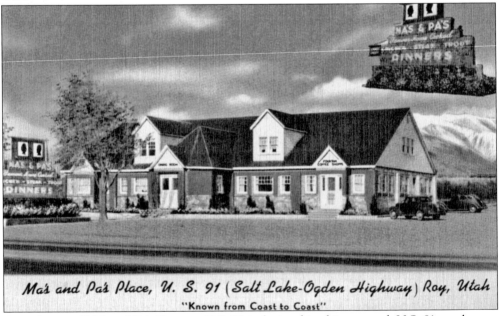

Ma's and Pa's Place, U. S. 91 (Salt Lake-Ogden Highway) Roy, Utah

"Known from Coast to Coast"

A rendering of Ma's and Pa's Place on U.S. 91 is depicted in this postcard. U.S. 91 was known as the Salt Lake–Ogden Highway. Ma's and Pa's claimed to be "known from coast to coast." They offered weary travelers their famous home-cooked chicken, steak, and trout dinners. The restaurant had a seating capacity of 600.

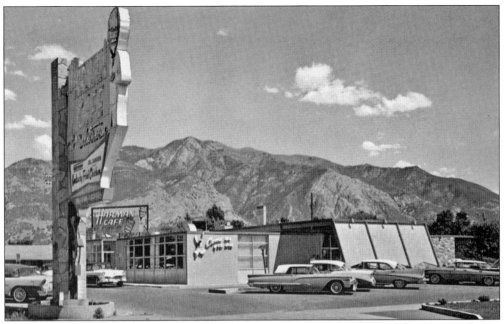

Harman's Millstream Café, located at 1412 Washington Boulevard, offered four private dining rooms to its patrons. The restaurant was located on the millstream that runs through Ogden and had a seating capacity of 365. In the air-conditioned dining rooms, a client could indulge in the Colonel's Famous Kentucky Fried Chicken.

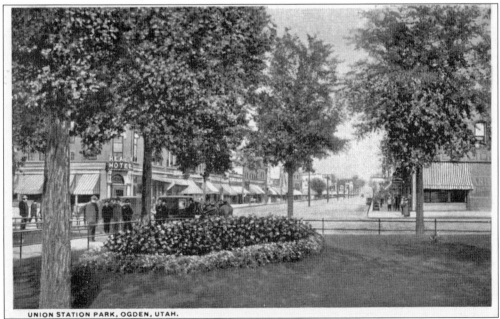

This postcard, sent in the 1920s from "Harriet" on her way home to San Francisco, California, to family in Virginia, shows the beautiful Union Station Park. Located on the grounds of the Union Station, the park gave tourists arriving off the trains a warm welcome into Ogden and shielded some of the bustling of Twenty-fifth Street. The postcard shows the Healy Hotel and the numerous businesses that lined Twenty-fifth Street.

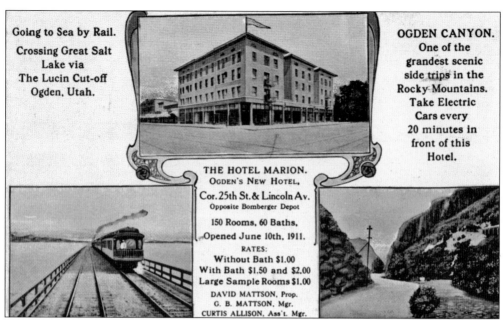

Going to Sea by Rail.

Crossing Great Salt Lake via The Lucin Cut-off Ogden, Utah.

THE HOTEL MARION.
OGDEN'S NEW HOTEL,
Cor. 25th St. & Lincoln Av.
Opposite Bomberger Depot

150 Rooms, 60 Baths,
Opened June 10th, 1911.
RATES:
Without Bath $1.00
With Bath $1.50 and $2.00
Large Sample Rooms $1.00
DAVID MATTSON, Prop.
G. B. MATTSON, Mgr.
CURTIS ALLISON, Ass't. Mgr.

OGDEN CANYON.
One of the grandest scenic side trips in the Rocky Mountains. Take Electric Cars every 20 minutes in front of this Hotel.

Travel by rail is depicted in this postcard. The Lucin Cut-Off allowed passengers to cross the Great Salt Lake by rail. The electric cars that ran up the Ogden Canyon daily took tourists on one of the grandest scenic trips in the Rocky Mountains. The postcard also showcases Ogden's newest hotel at that time, Hotel Marion, which was built in 1911. It was located just opposite the Bamberger Depot.

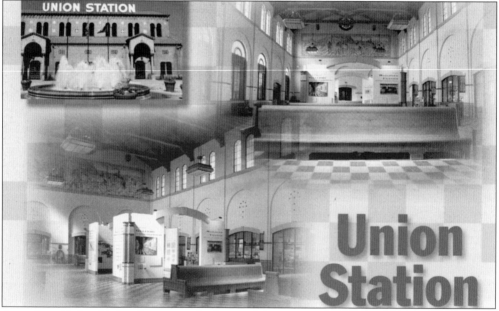

A modern Ogden Union Station is the focus of this postcard. The photographs show off the beauty of the main lobby in the station. Although the station was turned into a museum because of the dramatic decrease of railroad traffic, the Union Station Foundation has restored the benches and tiled floor that greeted many tourists as they arrived or boarded the trains to other destinations.

At the entrance to the beautiful Ogden Canyon is the Ogden Municipal Golf Course, now known as El Monte Golf Course. This course is one of the most popular ones in the state of Utah. Its friendly atmosphere and romantic setting are responsible, in part, for this popularity. Built in 1930, the golf course clubhouse is one of only 13 in the country to be on the National Register of Historic Places.

8302. Idlewild, Ogden Canyon, Utah.

The Idlewild Resort was built by the Winslow family in the early 1900s on the south side of Ogden Canyon, where Wheeler Creek flows into the Ogden River. Resort guests could eat at the resort restaurant, rent boats to use on Wheeler Creek, have picnics, and just enjoy the overall atmosphere of the canyon. The land is now home to the Thiokol Center.

125

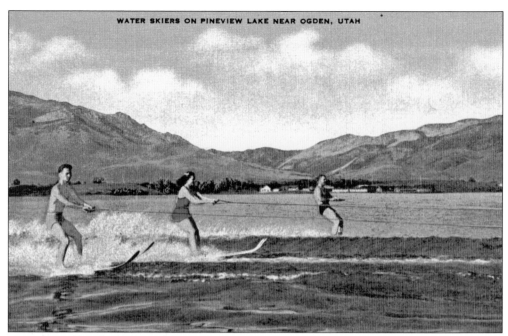

Pineview Lake offered a quick summer getaway for the citizens and tourists to Ogden. This postcard depicts water skiers as they are pulled from a motorboat traveling 30 miles per hour. Pineview is also used for camping, boating, fishing, and personal watercraft. In 1996, nearly one million people visited Pineview.

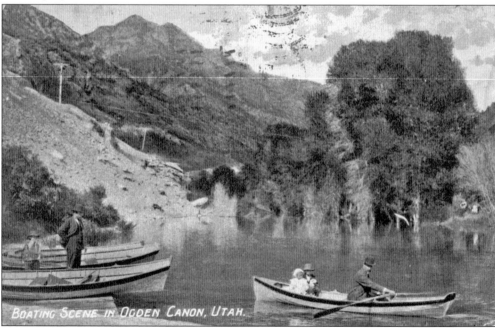

Sent in 1909 from a tourist passing through Ogden on her way to Denver, this postcard depicts an idealized scene of boaters in Ogden Canyon. One can see a man rowing with two children in the background in their Sunday best dress. The canyon during the early 20th century supplied recreational getaways for families to enjoy the beauty and grandeur that surround Ogden.

BIBLIOGRAPHY

Alexander, Thomas G. "Ogden: A Federal Colony in Utah." *Utah Historical Quarterly* No. 47 (Summer 1979): 291–309.

Doxey, Clifford. "The History of Ogden Public Schools." Master's thesis. Salt Lake City, UT: University of Utah, 1944.

Hight, Cliff. "The Era of Lasorda: The Ogden Dodgers, 1966–68." Senior thesis, Department of History. Ogden, UT: Weber State University, 2002.

Hunter, Milton R. *Beneath Ben Lomond's Peak: A History of Weber County, 1824–1900, Fifth Edition.* Salt Lake City, UT: Quality Press, 1995.

Kotter, Richard. "An Examination of Mormon and Non-Mormon Influences in Ogden City Politics, 1847–1996." Master's thesis. Salt Lake City, UT: University of Utah, 1967.

Ogden Sesquicentennial Committee. *Ogden City: The First 150 Years, 1851–2001.* Ogden, UT: self-published, 2002.

Ogden City Council Office. *Ogden City Councils and Mayors, 1851–2001.* Ogden, UT: Ogden City, 2000.

Peterson, F. Ross, and Robert E. Parson. *Ogden City, Its Governmental Legacy: A Sesquicentennial History.* Ogden, UT: Chapelle Limited, 2001.

Roberts, Richard C., and Richard W. Sadler. *Ogden: Junction City.* Northridge, CA: Windsor Publications, 1985.

———. *A History of Weber County.* Salt Lake City, UT: Utah State Historical Society, 1997.

Roybal, Linda. "Ogden's Twenty-fifth Street: The Spaces of Which Legends are Made." Master's thesis. Logan, UT: Utah State University, 1997.

Sadler, Richard W. *Weber State College: A Centennial History.* Salt Lake City, UT: Publishers Press, 1989.

Strack, Don. *Ogden Rails: A History of Ogden Railroads from 1869 to Today.* Ogden, UT: Golden Spike Chapter, Railway and Locomotive Historical Society, 1997.

Tillotson, Elizabeth. *A History of Ogden.* Ogden, UT: Ogden City, 1960.

White, Jean Bickmore. "The Right to Be Different: Ogden and Weber County Politics, 1850–1924. *Utah Historical Quarterly* (Summer 1979): 254–72.

www.arcadiapublishing.com

Discover books about the town where you grew up, the cities where your friends and families live, the town where your parents met, or even that retirement spot you've been dreaming about. Our Web site provides history lovers with exclusive deals, advanced notification about new titles, e-mail alerts of author events, and much more.

Find Your Place in History.